ArtBreak

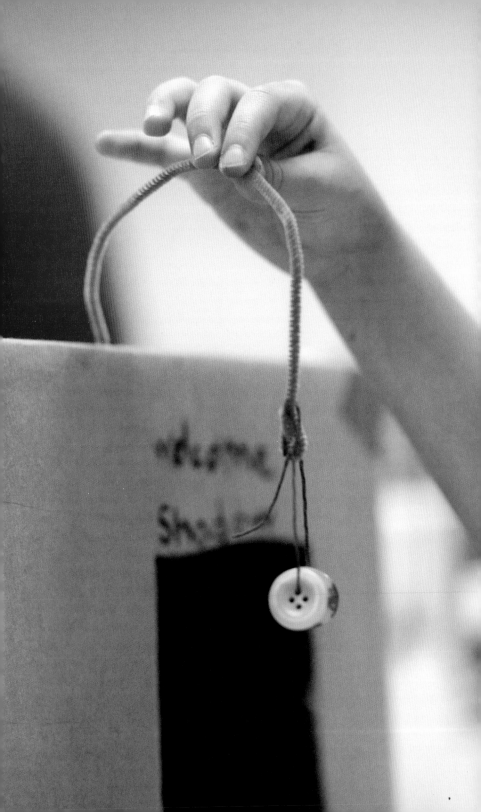

ArtBreak

a creative guide to joyful and
productive classrooms

Katherine Ziff

SWALLOW PRESS

Athens, Ohio

Swallow Press
An imprint of Ohio University Press, Athens, Ohio 45701
ohioswallow.com

To obtain permission to quote, reprint, or otherwise reproduce or distribute
material from Swallow Press / Ohio University Press publications, please contact
our rights and permissions department at (740) 593-1154 or (740) 593-4536 (fax).

Printed in the United States of America
Swallow Press / Ohio University Press books are printed on acid-free paper ⊗ ™

26 25 24 23 22 21 20 19 18 17 16 5 4 3 2 1

ArtBreak® is a registered trademark of Briarwood Studios, Athens LLC.

Library of Congress Cataloging-in-Publication Data
Names: Ziff, Katherine K., author.
Title: Artbreak : a creative guide to joyful and productive classrooms /
 Katherine Ziff.
Description: Athens, Ohio : Swallow Press, 2016. | Includes bibliographical
 references and index.
Identifiers: LCCN 2016008777| ISBN 9780804011723 (paperback) | ISBN
 9780804040723 (pdf)
Subjects: LCSH: Art—Study and teaching (Elementary)—Activity programs. |
 Education, Elementary—Activity programs. | BISAC: EDUCATION / General. |
 ART / General. | PSYCHOLOGY / Creative Ability.
Classification: LCC N362 .Z54 2016 | DDC 372.5/044—dc23
LC record available at https://lccn.loc.gov/2016008777

ArtBreak: A Creative Guide to Joyful and Productive Classrooms is dedicated to Project LAUNCH, an initiative of the federal Substance Abuse and Mental Health Services Administration (SAMHSA) designed to promote the wellness of young children from birth to eight years of age. The Ohio Department of Health provided support from this SAMHSA grant to Ohio University, which worked in partnership with the nonprofit, Integrating Professionals for Appalachian Children (IPAC), a network of agencies in the southeast Ohio region. The local Project LAUNCH director, Dr. Dawn Graham of Ohio University's Heritage College of Osteopathic Medicine, encouraged development of the program and facilitated funding for three summers of ArtBreak in collaboration with children's librarians at public libraries throughout the region. It is our hope that this book will help further the goals of Project LAUNCH and inspire others to build creative spaces in their schools, libraries, and other organizations.

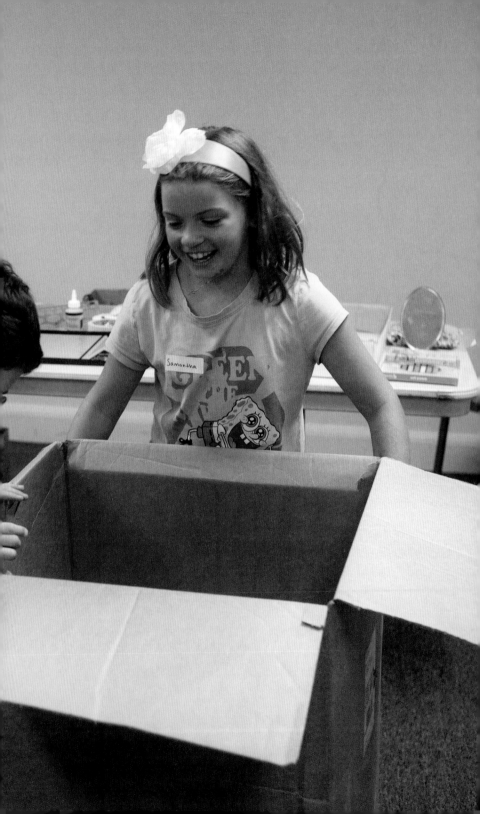

CONTENTS

RESOURCES

PREFACE

IN 2008 I began an ArtBreak journey with twenty-nine children in an elementary school in southeastern Ohio where for six years I was a school counselor. I thought to meet the diverse needs of the children referred to my office with a model I had learned about years ago: a small-group art studio that was part of a Medicine and Art class taught by Mary Anne Bartley at the Medical College of Pennsylvania in Philadelphia. Her art studio was designed to be a restorative place to support learning. There medical students, "dragging their cares and woes," relaxed, expressed themselves, allowed creativity to flow, and emerged as active learners "ready to tackle whatever they confront from new and more productive directions." My thought was: "If an art break could do this for medical students, what might it do for schoolchildren?"

The inspiration of this medical-school-based atelier combined with what I discovered in Lisa Hinz's book on the expressive therapies continuum (ETC), a theory from art therapy, gave form to the creative counseling program for children dubbed ArtBreak. I drew on two more theoretical streams to work out and complete the structure: child-centered education, as elucidated by Carl Rogers, and the developmental stages of group counseling. ArtBreak is therefore a program that works across traditional disciplinary boundaries, integrating theoretical frameworks from counseling, art therapy, and child-centered education.

The purpose of this book is to share the how-to's of ArtBreak with educators, counselors, social workers, psychologists, families, children's librarians, and others who work with children. The book includes much detail and attention to methods and materials, the purpose of which is to support readers in using art materials with confidence and working with an authentic child-centered focus.

Much, if not most, of traditional schooling is not truly child centered. (If it were our schools would look a lot different.) A shift in mindset is required to provide such an experience. By way of example, throughout the book I illustrate my own progress (and stumbles) in working toward a child-centered focus.

ArtBreak allows children to relax and provides them with an opportunity to express feelings; improve social skills; find community; engage in teamwork; develop empathy; hone cognitive skills; practice problem solving; build imagination and persistence; and, for some, engage in work that is transformative and deeply healing. I have experienced the work as an exhilarating challenge, a journey with children through the school year that is joyful, productive, sometimes poignant and difficult, often humorous, and always seeking to be supportive of child-directed learning.

This work is based on a year of planning and five years of offering the program in two schools to about 150 children (in kindergarten through sixth grade) in over 350 weekly small-group sessions. It was also piloted in a middle-school academic support program and expanded into individual elementary classrooms. A summer version of ArtBreak was supported as a public-library-based summer studio by a grant from the federal Substance Abuse and Mental Health Services Administration's (SAMHSA's) Project LAUNCH. The program has been peer reviewed in national publications and professional conference presentations.

I have masked in various ways the name identities of the children. Their families gave permission for their work to be used for purposes of teaching and research, and the school district gave its institutional blessing on the research that we undertook.

The program's development owes greatly to the friendship and consultation of Margaret King, early-childhood educator emerita at Ohio University, gardener, and photographer, who guided me to fully appreciate and have the courage to try my idea of a child-centered studio. Dr. King was quick to point out the benefits of the program's child-centered approach and encouraged me constantly. She donated materials; delighted in my accounts of student-directed

turns of events in the studio and interpreted their importance to me; suggested scholarly resources to build the theoretical framework; cheerfully admonished me when I strayed from a student-centered mindset; and gave me tours of her beautiful flower garden that flourishes in a profusion of abundance and diversity.

School district teachers and administrators were critical to developing and maintaining the program. Families, teachers, and school staff embraced the program, filled it year after year with referrals, and donated all kinds of things to fill our studio shelves. Thanks also for the support and expertise of Lori Pierce, Sue Johanson, Jeremy Yehl, Heather Skinner, Denny Boger, and Kacey Cottrill (who bought the studio's red drying rack). Art educators Tami Benyei and Theresa House recognized what I was trying to do, shared materials, and suggested better ways to do things. My school counseling colleagues Patsy Barrington, Sean Kelbley, and Emily Dodd were unfailingly optimistic and supportive. My husband, Matthew, cheerfully fell in with the project and for five years gave advice and encouragement from his perspective as a design educator, helped me scrounge cardboard boxes, saved jar lids, and donated throw-aways from his workplace. When one of our groups asked for lighting for a winter-holiday installation, my son Ben, trained as a theater electrician, came out and provided beautiful light and shadow effects for the school to enjoy. Dawn Graham and Jane Hamel-Lambert at Ohio University's Heritage College of Osteopathic Medicine provided encouragement and Project LAUNCH funding for three summers of an ArtBreak collaboration with children's librarians at the community libraries in Athens, Meigs, Vinton, and Hocking Counties, which were documented by photographer Josh Birnbaum. His photographs of the summer programs illustrate this book.

Thank you to the *Journal of Creativity in Mental Health* for permission to use a table and vignettes from an article published in the journal in 2012. My Wake Forest colleagues Nathaniel Ivers and Edward Shaw provided statistical expertise, an advanced perspective on implications of the program for child-stress mitigation, and collaboration on an article in the *Journal for Specialists in Group Work*.

Sam Gladding, teacher and colleague, has, through his scholarship and work with the American Counseling Association, created an enduring framework to support counselors to professionally engage creativity in our practices. Gillian Berchowitz and her colleagues at the Ohio University Press are both expert and gracious in their work, generous with advice and analysis, and supportive of creative process at all levels and venues. Finally to my ArtBreak partners and astute teachers, the children: thank you, take care of each other, and take care of the stuff.

PART I

FOUNDATIONS

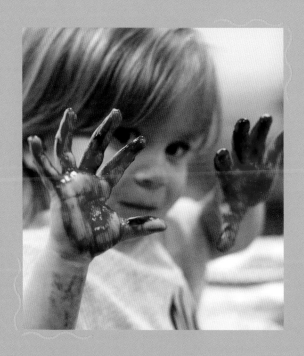

Why ArtBreak?

"We make things for the joy of it."

—*Fourth Grader*

P LAY IS THE central, universally significant activity of child-
hood. Self-directed play, in which adults play a supporting
rather than a directing role, is critical to the well-being of children.
Gary Landreth in *Play Therapy: The Art of the Relationship* notes that
play, essential to the natural development and wholeness of chil-
dren, is a universal right of children everywhere. But, as Peter Gray
presents so compellingly in *Free to Learn*, as opportunities for play
in the United States have disappeared over the last half century,
rates of mood and anxiety disorders have risen among children.

Children's days and nights are scripted and planned for them,
and, in attempting to respond to the political imperatives of school
reform in America, schools contribute to the restrictions in the lives
of children. Homework intrudes into family life. Recess is curtailed
to make time to raise standardized test scores or to serve as punish-
ment for children who have misbehaved or failed to turn in their
homework. Instruction in the arts is sacrificed to exigencies of

budgets. Playtime for children has all but disappeared, and school itself has been documented as a major stressor in their lives. Yet the research on play tells of its vital benefits. Elise Belknap and Richard Hazler's article aptly entitled "Empty Playgrounds and Anxious Children" reviews the scientific research documenting the substantial role of play in supporting the development of

- Divergent thinking
- Literacy skills like creating and working with narratives
- Practice with numerical concepts
- Personality characteristics like curiosity, perseverance, self-regulation, optimism, concentration, engagement and motivation
- Prosocial behavior like accommodating and negotiating with others
- Internal locus of control
- Expression of feelings and experiences
- Problem solving, memory, and cognitive flexibility

The relationship between play and learning, in fact, is so strong as to suggest that play is critical to learning. And children can conceive of just about anything, including working with art materials, as an opportunity for play. Through play with material like paints, clay, drawing media, blocks, and cardboard, children begin the work of developing creativity that eventually leads to an ability to produce and modify complex and organized fields.

What is play? Peter Gray in *Free to Learn* devotes seventeen pages to a definition and gives three general guidelines for explaining play. Play has to do less with an activity itself and more with attitude and motivation. Play can be woven into other activities, bringing a playful attitude to whatever activity in which one is engaged. And "pure" play has five characteristics:

1. It is self-chosen and self-directed.
2. Its means are valued more than the ends.
3. Its structure comes from the minds of those who are playing.
4. It is mentally removed from "real" or "serious" life.
5. It involves an active and non-stressed state of mind.

Doris Bergen developed a taxonomy of play based on the level of self-direction held by the child: *Free play* is child directed and supports a discovery style of learning; *guided play* involves an adult contributing support and encouragement. In contrast, *directed play* and *work disguised as play* involve an adult as the director and a child as the recipient.

Play also has the potential to create for children positively toned emotions known as "uplifts" that can mitigate both chronic and traumatic stress. Such positive experiences can provide a break from a stressful environment, allow children to experience positive stressors that generate excitement and hope, and promote restorative healing from a stressful event. In school, such a play break can allow a child to return, refreshed, to the classroom better able to engage in academics.

ArtBreak is a choice-based, guided-play experience based on the developmental and restorative possibilities of art making. Our action research documentation for the program tells us that children enjoy and value it, teachers and families appreciate it, and it lowers stress levels for children. It is easy to implement: you can start right away in your classroom or home, at whatever scale suits your space, time, and budget. And no art training is required, only the willingness to embark on a play journey with children. This book is a step-by-step "how to" for creating and facilitating an ArtBreak group for children that meets the needs of your time, space, and budget.

Children flourish when they experience engagement, belonging, and joy. In a working laboratory featuring both freedom and order where their innate curiosity, playfulness, and sociability are guided by their own interests and questions, children are able to find a natural balance. In ArtBreak such a balance is created through a social/emotional framework designed to support community, work, relaxation, problem solving, creativity, and imagination. As schools are working to meet the requirements of new evaluations and assessments, they are asked to also master the delivery of new curricula and encouraged to infuse their classrooms with twenty-first-century skill building: creativity, critical thinking and problem

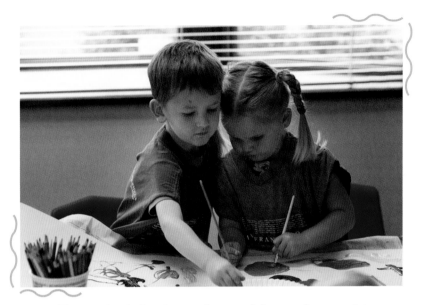

These two worked out how to choose and share a palette to paint one big picture together. *Photo by Josh Birnbaum*

solving, communication, and collaboration. These skills are best learned in an atmosphere that recognizes school as a social-emotional place.

This book is a practical guide for educators and families who wish to offer children an ArtBreak program grounded in social/emotional learning and based on the restorative possibilities of art making. *No art experience or training is needed.* You may have picked up this book because the thought of a joyful, productive classroom is compelling. Yet, on the other hand, it sometimes seems impossible. At no time during the last hundred years of public education has so much been expected of schools, teachers, and children. Much of the current American conversation about school reform binds public-education policies to the service of national economic interests, emphasizing children as beings to be shaped to fit an undefined future based on competition. At the same time schools face challenges of every kind—funding, standardized achievement

test performance mandates, drop-out rates that approach 50 percent in some demographic groups, political hostility to teachers, achievement gaps, and children deeply affected by environmental stressors such as poverty and trauma and, indeed, the stress imposed by schools themselves.

An ArtBreak program offers children freedom of choice in art making within a community guided by flexibility and individualization, where they are always supported and sometimes guided. In ArtBreak settings children meet weekly for a forty-minute, choice-based art experience throughout the school year. ArtBreak's organizing framework is the expressive therapies continuum (ETC), a theory from art therapy based on the restorative and creative possibilities of art making. The ETC describes the functions of art materials according to how fluid or resistive they are. Fluid media like watercolor and finger paint support kinesthetic and sensory goals like relaxation and expression of feelings. More resistive media like colored pencils and markers support perceptual and affective goals such as identifying emotions, understanding cause and effect, and creating narratives. Highly resistive media like collage and construction develop problem-solving skills. A creative strand runs through all three levels and can occur at any point along the continuum.

You can conduct an ArtBreak with an entire classroom, with a small group composed of children from different classrooms, or in a home with children of various ages. I have partnered with classroom teachers and worked solo by using a pop-up studio stored in bins, an entire room dedicated to the studio, and a hand-built, sketchbook-based version—in schools as well as in community settings like libraries. Regardless of the setting, ArtBreak groups develop their own personalities yet evolve through common stages. This session, originally published in the *Journal of Creativity in Mental Health*, illustrates an ArtBreak group in its ninth session in which children are working independently with different media.

> Six children, ages five through eleven years, rush into the school counselor's room and dive into the apron box for smocks. It is time for ArtBreak. Two students head for the back table where

their cardboard robots are ready for them; they have been under construction for several weeks now, and today the students would decide to work on the problem of how to create and attach movable arms. A second grader circles the room a time or two before settling on finger paint, choosing glossy paper and a selection of paints and carefully squeezing out globs of paint, while exclaiming over the bright hues and squishy feel of the paint. A fourth grader reaches for her cardboard-and-duct-tape construction and continues to grapple with how she will make a sturdy and meaningful object. Another child walks about the room eyeing paints, boxes of collage materials, and the construction corner stacked with cardboard and other repurposed objects. This child selects a five-gallon plastic jug, mixes tempera paint, and covers the jug with a turquoise and green under-the-seascape. Filling the jug with water makes it hard to handle, so a handful of glass pebbles serves as seawater. A sixth child works carefully on a valentine collage for a sibling. "Where's the music?" one child shouts. Oops—the counselor forgot to turn it on, and she hits the start button for the jazz CD the group has become accustomed to. The children work steadily for half an hour, talking among themselves and occasionally offering announcements to the group. The counselor moves around the room, supporting problem solving by offering tools, assistance with hole punching, towels when water spills, and a basket of new string and yarn. She occasionally pauses to make notes about what the children are doing and saying. The children try to eke out a few more minutes past the allotted half hour of work time and then help with a whirlwind cleanup. Art is stacked on a rack to dry, and the counselor takes five minutes to write down notes about the group's process and reminders about materials or room rearrangements needed. Morning ArtBreak ends; the counselor gets the room ready for the rest of the day that will include an afternoon session with a different group.

Researchers have sought to find a causal relationship between students' participation in the arts and school achievement as measured by grades and test scores since at least the 1980s. After decades of trying to document the claim that arts education transfers to academic (math and reading) learning, some of the leading scholars engaged in this work have concluded that the best way for students

to develop math skills, for example, is to study math. Instead, research on arts experiences in schools has refocused on the kinds of outcomes that school-based arts experiences *do* have. For this reason it is an exciting time to be working with and researching art making in schools. Ellen Winner and her colleagues, for example, have documented eight studio "habits of mind," or thinking dispositions, taught by visual-arts educators, such as development of craft, engagement and persistence, and ability to reflect, observe, envision and express.

As the ArtBreak groups progressed, we undertook practitioner-based action research to try to fine-tune operations and inform improvements. We also wanted to understand the contribution of the program toward child well-being. Specifically we sought to understand whether the groups mitigated child stress, and whether the groups seemed to support the developmental goals derived from the expressive therapies continuum framework that we incorporated into our referral procedures.

We learned that children relax in ArtBreak. This is apparent when you observe them in the studio, and it is supported by our ArtBreak studio research involving the biological measure of fingertip temperature, a reliable biomarker of stress levels. As a person relaxes, blood vessels in the extremities dilate (vasodilation), blood flows more freely to the hands, and fingertip temperature rises. For two years we measured changes in fingertip temperature among thirty-nine ArtBreak students as they entered the studio and then about two-thirds of the way through the session (before they began to wash their hands and clean up). We found an average increase of +4.6 degrees F while children were engaged in making art during a group session; nearly all students in the program experienced some level of relaxation. Further statistical analysis (t-tests) showed an overall significant increase in temperature. We discussed, but elected not to pursue, an experimental design with a control group, because of the logistical considerations required as well as ethical concerns about diverting children who had been referred to ArtBreak to another intervention. With this in mind, the research, although suggestive, supports the idea that the program reduces child stress.

Mitigation of child stress is important. Traumatic events as well as cumulative chronic stressors from factors like poverty, racism, difficult family circumstances, and school itself take their toll on a child's psychological and physical health. Schools have the potential to create opportunities for islands of stress reduction throughout the school day, and researchers have noted three kinds of such "stress-buffers." ArtBreak has the potential to offer all three. *Breathers* are positive events in the midst of stress that allow a child to take a break and recover. *Sustainers* are enjoyable challenges that sustain coping and allow a child to notice that positive feelings like optimism can be experienced in the face of stressors like the challenge of problem solving that can occur while making art. Finally, *restorers* are recuperative healing experiences that follow a stressful event.

Materials developed and collected at various times throughout the program included the facilitator's reflective notes and journals, the children's reflective journals, photographs of student work, the children's verbal responses to questions and prompts about their experience and learning, written teacher assessments, and data created from referral forms.

In terms of our process and perception data, about half of our participants were referred to help them develop pro-social behaviors and understand their own strengths; about a quarter were referred for an opportunity to relax and express their feelings; and a quarter were referred to work on strengthening their problem-solving abilities. About two-thirds of the participants were boys. When we asked teachers about their perceptions of student progress on their individual reasons for referral, about 70 percent of the students were thought to have made gains and 30 percent were thought to have remained the same. This process informed adjustments like extending the session length from thirty to forty minutes, confirmed that the expressive therapies continuum is useful for structuring individual referral goals, helped gain funding for a summer program, and gave us an understanding of how ArtBreak supports children. For practical purposes, documenting provides reflective time and

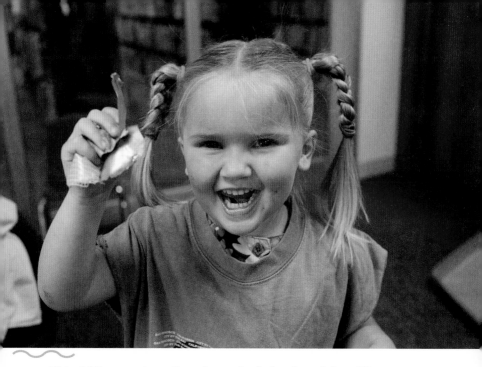

This child's expression reflects the words of a fourth-grade boy: "We make things for the joy of it!" *Photo by Josh Birnbaum*

space for a facilitator to attend to group process as well as to create an archive of photographs and notes to use for ArtBreak "progress reports" for families, teachers, and students. Throughout the book you'll see examples and case accounts that illustrate the ways children progressed.

What follows here are summaries of what we learned about categories of student gains.

JOY AND FUN

Most often children talked about having fun in ArtBreak. Along these lines they also mentioned joy.

"We have fun!"

"We make things for the joy of it!"

EMOTIONAL REGULATION AND SENSORY EXPRESSION

ArtBreak allows children to express their feelings and enjoy a sensory experience. When asked what they have learned, some children talk about feelings and that ArtBreak helps them enter a state of calmness.

"Finger painting feels good; it is awesome and smooth."

"I learn I have to work calmly in here."

"If you're mad, you calm down."

"It helps me control my anger, because you sit down with me and paint."

Teachers noted gains in emotional regulation:

"(He) seems very happy and content, not upset if things aren't 'just right.' He has come mega-miles."

"(He) is better able to work in small-group settings, making less noise and creating fewer distractions. ArtBreak was perfect for him."

"(She) still can get easily upset, especially when she is disorganized or feels pressure, but I have seen improvements in her ability to calm herself down and try to be more organized."

The choice-based, child-directed environment and inviting art materials create a support and comfort that children respond to with a relaxation response of increased blood flow to the limbs, which warms their hands, a reliable indicator of stress reduction that we were able to document.

Attending to the nature of lighting and music in the studio contributes to an environment of calmness and warmth. The children themselves are often drawn to choose work that is calming when they need it, and it usually involves fluid media. One year a fourth grader spent most of his time at the sink rinsing paintbrushes that he gathered from the worktable or swishing his hands in a dishpan he had filled with water. This sensory experience was soothing for

him and allowed him to return to his classroom relaxed. The next year he began painting, reveling in finger paint and painting his hands with a brush. Sometimes he made prints with his painted hands. In sixth grade he began sewing. Sewing is a highly cognitive activity when it comes to measuring and cutting, but the rhythm and repetition of hand sewing with a running stitch can be quite relaxing. In this way he began, when he was ready, to integrate problem-solving and cognitive processes into his work. Occasionally I have noticed a child who is struggling in frustration with a technical task—fastening boxes together, stringing beads just so, drawing a certain shape—put that work aside to do a little finger painting instead.

SOCIAL SKILLS AND COMMUNITY

Sometimes the main task of an ArtBreak group is to learn to become a working community. With some groups I have had to remind myself of the stages of group process, and that we will get through the norming and storming period, outlined in chapter 2, and reach the working stage. An ArtBreak community develops through the process of making art together.

When working with a small group of boys referred to an Art-Break group created just for them at the request of the school intervention team because the once-close group of friends had been constantly arguing and fighting, I despaired for several sessions of anything occurring except the flinging of materials and insults. Then the boys all decided they would make knotted and woven necklaces of twine. This was very bad news to me as, although we had a roll of twine, I had no idea how to use it to make complicated necklaces. "Not to worry," they said. They opened my laptop, searched for and found YouTube instructions, and, arranging themselves in a semi-circle around the computer, taught each other how to make macramé jewelry. They razzed each other for being slow to learn and awkward with their fingers, but they determined who was the best at necklace making and demanded that he help them with the tricky

parts. For three sessions they sat companionably teaching each other and producing necklaces; this was a turning point for the group from confusion to collaboration and productivity (or, in group process language, from storming to norming), and provided confirmation for me of the power of attending to child-directed learning and group process. Their teachers noticed that their fighting stopped.

During a session early in the year a child used a plastic egg, plastic googly eyes, and a wooden spool to sculpt a little figure with a poignant expression. A bit uncertain socially, she seemed to have made a self-portrait. Through the year she blossomed socially in ArtBreak and extended this experience to her classroom, playing with others at recess and getting herself elected to the student council.

Children talked about the social aspects of ArtBreak:

"We make new friends."

"We learn to be creative and be a good sport . . . we support each other."

Teachers commented about gains in social skills:

"He is a natural leader. This can sometimes be a good or not-so-good thing. ArtBreak gave him an opportunity to hone those positive leadership skills."

"Above all, he benefited most from ArtBreak. He has friends, has been accepted/celebrated for his art abilities, and is, overall, more confident and embraced by his peers."

"He handled recess better, was able to join in play with others more easily."

"Every child looked forward to ArtBreak, especially _____. She felt part of a group and gained self-confidence as a result."

PROBLEM SOLVING AND COGNITIVE SKILLS

I have noticed that children master the technical skills they need to accomplish their purposes in ArtBreak mostly by doing, observing the results, and re-doing. When asked what they learned they talked about skills:

"We learn about tools, what you can make with them, being careful with them."

"I learned how to make a robot, how to sew."

"You use your thinking, you think about what you make."

"If your paint gets kind of dry, you can draw and scratch things in it."

In *How Learning Works*, Susan Ambrose and her co-authors describe process tasks for developing self-directed learners. This takes place in ArtBreak through choice and problem-solving questions. The steps are

Self-Directed Learner: Process Tasks	*ArtBreak Participant:* Questions
Assess the task	What work will I choose today?
Evaluate strengths and weaknesses	What materials, tools and help do I need?
Make a plan	What is my plan for doing this work?
Apply strategies and monitor performance	How is this working out?
Reflect and adjust if needed	What is my next step?

A third grader who enjoyed constructing animal figures with small boxes found it of great importance to have his projects turn out exactly as he envisioned, and sometimes the scope of his concept was way beyond the spatial-thinking skills of an eight-year-old. I respected his firmness in making his own decisions about designing, measuring, and cutting, holding my tongue (with difficulty) when I was bursting to intervene with corrections. Nevertheless, he persisted, sometimes retreating to a chair outside the door to collect himself when his frustration became too great, but always returning to try again. A child stayed after a group one day to finish painting a collage of a snowman on a huge sheet of blue paper ornamented at the bottom with pink paper and duct tape. When he finished he stood close to me and told me quietly: "My parents are amazed that

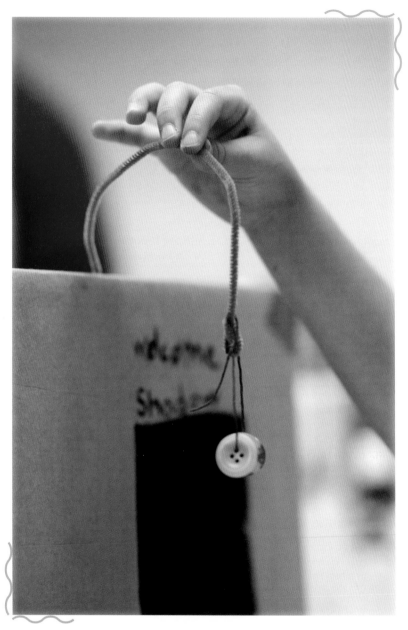

Problem solving the construction of a doorknocker for a cardboard house takes ingenuity. *Photo by Josh Birnbaum*

I make these things. They say, 'How did you make this?' And I get out stuff and I show them."

Community art making supports collaborative problem solving. Some children choose to work in teams. Two first-grade boys in an ArtBreak group began working together, first as a collaboration when one recruited the other when he needed help building a long communication device using cardboard tubes and tape. They continued this partnership through the year, and as they were in the same classroom they sometimes planned their work in advance. One day they came in and announced: "Today we will paint," and then asked, "What will we paint?" I encouraged them to look around and see what they would like to paint. Together they discovered two Styrofoam cubes and attached them with tape. On their own they donned smocks and prepared a palette of yellow, blue, and red paint—three inviting pools of primary color. First, they made a lime green and gave the cubes their first coat. We exclaimed over the beauty of this green and I had to hold back to keep from urging them to leave some of that color when they added red. But the joy of red prevailed and the cubes turned a khaki color.

The boys painted and painted and noticed that they could carve their names in the cubes and reveal the lime green. They painted right back over the etched green letters, and then it was time to go. "Who would take the cubes home, taped together as they were?" they asked each other. They asked if I would use my mat knife to cut the tape. This was done and they found flat boxes for each wet cube. That afternoon I spotted them carefully carrying the painted cubes out of the school to the bus. Another year a sixth-grade boy came to my room for help in solving a friendship problem. After we finished that work he sat back and mused about the ArtBreak group he had participated with in fourth grade, remembering things long forgotten by me. "Do you remember how William (a boy two years his senior) helped me? We made Mario figures together. He showed me about the clay."

A teacher-educator visited our studio and noted, "I was impressed with their confidence and persistence in trying various ways to present their ideas." Because children are naturally eager to bring their

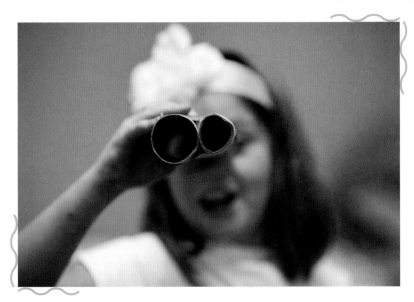

Play is a learning language for children. This child has made toy
binoculars to play with. *Photo by Josh Birnbaum*

ideas into form, if they are confident in their use of materials and
their ability to ask for and receive help, they will tackle all kinds of
problems. Here is a list of a few problems and questions engaged in
ArtBreak sessions:

> How to make a sturdy airplane wing?
>
> What does a dragon look like?
>
> How to cover cardboard tubes with pink color?
>
> How to reinforce cardboard to make a tunnel?
>
> How to paint a picture of a seashell?
>
> How to attach a handmade flag to a pole?
>
> How to get artwork home safely?
>
> What is the best material for robot fingers?
>
> What might best be used for a robot brain?
>
> How to tie a strong knot that does not come undone?
>
> How to make working doors in a cardboard Barbie house?

How to attach a cardboard tube to a cardboard box?

What does a flute look like?

What to do if I do not like my painting?

How to make a retractable light saber?

Can pink be for boys too?

What's the best way to make a trap that works?

How many stars are on the American flag?

How to make a skirt?

IMAGINATION AND SELF-DIRECTION

A sixth-grade boy, when asked to describe ArtBreak, gave us this nugget of wisdom about choice, a condition that allows creativity to flourish: "We aren't directed. Your mind is not in a can." Another student offered: "We don't get told what to do, what to make. We have ideas."

The ArtBreak framework creates conditions that allow imagination and imaginative play to flourish. I learned this early on when I could not understand the source of the children's enthusiasm about making things. In 1977, social worker and philosopher Edith Cobb wrote that a child engages imagination and creativity "through the controlled poise of his own body, through the sense and vision of his own hands moving pieces of his world into structure and pattern." During a session in which children were making lots of cardboard objects (drums, dolls, small vehicles), hurrying to finish so that they might take them home, I asked, "What do you do with them at home?" The children put down their scissors and tape and cardboard, looked at me in disbelieving pity and chorused: "We play with them!" Of course, they were making toys! And they were incredulous that I could not recognize what they were doing. Absorbed in spontaneous mental images of things they wanted to play with, and inspired by the materials at hand, they were completely engaged in bringing their creative visions into form.

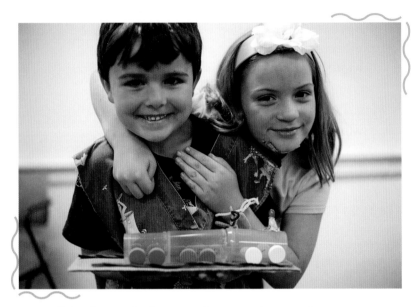

Relatedness with others grows from an environment that supports working together. *Photo by Josh Birnbaum*

ArtBreak creates school engagement in part by offering fun. The idea of fun and joy as a companion to learning and well-being is enjoying a revival, though fun can be a suspect notion in schools. I felt that our work bordered on frivolous, and even stopped writing down how children continually describe ArtBreak as "Fun!" until I read research on the learning benefits of fun. Fun creates engagement, meaning, purpose, and joy. Neurologist and classroom teacher Judy Willis argues "The truth is that when joy and comfort are scrubbed from the classroom . . . students' brains are distanced from effective information processing and long-term memory storage." Edith Cobb wrote that a sense of wonder, manifested as joy and surprise, is a prerogative of childhood and essential to the development of creative thinking. Martin Seligman, pioneer of positive psychology, believes positive emotions like fun are an essential part of happiness and well-being. And any kindergarten teacher can tell

you that fun, or engagement in meaningful activity, creates joyful, happy classrooms and productive work groups.

Children participating in an ArtBreak talked about imagination and engagement:

"ArtBreak is when you can express your 'magination."

"I watch the clock all day, waiting for 2:30. That's when I get to go to ArtBreak."

Imaginative play, fun, joy, choice, competence in problem solving, and belonging to a community are all linked with school engagement. Researchers Ming-Te Wang and Jacquelynne Eccles conceptualize engagement as behavioral (positive conduct and involvement in school tasks), emotional (positive reactions to school activities), and cognitive (willingness to exert necessary learning efforts). Engagement is created by a school context that supports children's needs for competence, autonomy, and relatedness to others. Art-Break is designed with all three needs in mind.

A TRAUMA-SENSITIVE SCHOOL CULTURE

ArtBreak supports a trauma-sensitive school culture. According to the American Psychological Association about half of children in the United States experience some kind of trauma, usually beginning in early childhood. Most recover, but a substantial number do not, with poverty a significant risk factor for both exposure and recovery. The Massachusetts Advocates for Children publication, *Helping Traumatized Children Learn*, provides an overview of the nature of childhood trauma and what schools might do to help. ArtBreak provides many of the things needed by children who have suffered trauma in order to thrive in schools. These include the opportunity to:

- move into a state of calmness from an alarm state
 Example: An eight-year-old, frantic because his father had been arrested the previous night, left a session calm after spending a half hour absorbed in art making.

- develop a sense of empowerment via choices

 Example: A child from a homeless family, delighted to learn that she had free choice of a rich variety of materials to bring her ideas into form, worked to build an elaborate dollhouse to her own specifications.

- practice using language to articulate needs and feelings and to problem solve

 Example: ArtBreak participants are encouraged to ask for what they need from each other and from the facilitator.

- learn about cause and effect relationships and recognize their own ability to affect what happens

- learn to attend to a task at hand, in a safe and predictable environment

- practice regulating emotions

 Example: A child who began the year screaming and throwing materials when frustrated with the outcome of his work learned to manage his feelings so that by year's end he could step away for a few minutes and then return to try again.

- practice executive functions like setting a goal, anticipating consequences, and carrying out plans

 Example: Construction projects, including sewing, support cognitive executive functions and require planning. Having decided to make a playhouse, a child made a sketch of what she had in mind, prepared a list of materials, thought through different ways to create doors and windows, and, through problem solving, made a door knocker in order to complete her project.

- learn these things in an environment in which they are not publicly labeled and featured as "traumatized" or "abused"

 Example: Children are not gathered into ArtBreak groups by mental health diagnoses or behavioral goals. Goals and functions of the expressive therapies continuum guide referrals, and groups are formed mostly to align with schedules rather than grade level or age.

ACADEMIC ALIGNMENT

ArtBreak is particularly aligned with mathematics skills, fitting well within such standards of mathematical practice as

- making sense of problems and persevering in solving them
 Example: A child finds a way to make movable arms and legs for a robot.

- using appropriate tools strategically
 Example: The participants measure and mark with rulers, use tape measures, use awls and brass fasteners, and punch holes strategically with a hand-held hole punch.

- attending to precision
 Example: The students calculate fabric yardage, find midpoints on objects, cut cardboard to exactly form a box lid, design a fastener, and design a pattern for a three-dimensional box.

- looking for and making use of structure
 Example: A child figures out how to make a wearable table.

- constructing viable arguments and critiquing the reasoning of others, at the elementary level elucidated as constructing arguments using concrete referents such as objects, drawings, diagrams, and actions
 Example: A student wanted to build a "hideout" and presented a diagram and a written plan supporting his request for two really large cardboard boxes.

ArtBreak's foundation is built on cardboard, paper, tape, paint, ribbons and strings, repurposed materials, and lots of ornamental doodads all chosen and organized with regard to the framework of the expressive therapies continuum. Its studio is a community of freedom and order that encourages expressiveness, problem solving, and creativity. The next chapter details the workings of the expressive therapies continuum and other elements of ArtBreak's creative framework.

A Creative Framework

"When I have been able to transform a group—and here I mean all the members of a group, myself included—into a community of learners, then the excitement has been almost beyond belief."

—*Carl Rogers*, The Carl Rogers Reader

A RT BREAK INCORPORATES three frameworks that integrate a manner in which to relate to children, a way to think about and offer art materials, and realistic expectations in terms of group dynamics. Formally the frameworks are known as child-centered education, the expressive therapies continuum (ETC), and Bruce Tuckman's developmental stages of group counseling.

CHILD-CENTERED EDUCATION

Child-centered education is associated with many contemporary descriptors of teaching and learning—including those that are active, collaborative, inquiry-based, and problem-based—many of which are related to the structure of lessons and classrooms. I find it helpful to go to the work of Carl Rogers and his person-centered theory of counseling and psychotherapy. A psychologist by training, at the end

of his career Rogers began to apply his humanistic theory to teaching and concluded in *Freedom to Learn* that "The only learning which significantly influences behavior is self-discovered, self-appropriated learning." This dynamic, which transfers power from the teacher to the student, is what informs student, or child-centered, education. Is there evidence that a person-centered environment is effective? *Yes.* In counseling and psychology we have known for decades about the importance of the relationship between client and therapist in creating positive outcomes in therapy. In education, as early as the 1960s, social psychologists were documenting the dimensions of a positive classroom climate and its role in supporting student learning. In recent years professional associations like the American Psychological Association through its initiative, The Other 3 Rs Model for Student Learning, elaborated by Rena Faye Subotnik and Robert J. Sternberg in *Optimizing Student Success in School with the Other Three Rs: Reasoning, Resilience, and Responsibility*; and the American School Counselor Association have re-affirmed the importance of social/emotional education in schools. Research studies have linked many aspects of social and emotional learning with gains in academic competence and found that arts programming with positive outcomes for children and young people are ones that attend to the social/emotional environment.

Carl Rogers emphasized the interpersonal relationship between teacher (referred to as the facilitator of learning) and students. He outlined three necessary qualities of a facilitator of learning: (1) realness; (2) prizing the learner; and (3) empathic understanding. Table 2.1 pairs these qualities with suggestions for ArtBreak.

Realness

Realness, or genuineness, is being transparent in one's feelings in a matter-of-fact way. In ArtBreak I am being real when I take time to be aware of my own feelings and try to express them in a constructive way.

Table 2.1. Qualities of a Child-Centered ArtBreak Facilitator

Facilitator Qualities	Features	What to Do
Realness	Transparency of feelings	Take time in the moment to be aware of your feelings; notice any clues your body gives you. Reflect on what your feelings might mean. Try to express feelings in a constructive way.
Prizing the Learner	Non-possessive caring Belief that the child is fundamentally trustworthy Valuing the child's choices Cultural sensitivity	Encourage child choice and control. Take child choices and intentions seriously. "Notice" instead of "like" a child's work so children work to accomplish their goals instead of to please the facilitator. Allow children to problem solve. Consider diversity and what it might mean for your studio.
Empathic Understanding	Understanding experience from a child's perspective Living the uncertainty of discovery	Reflect on ArtBreak sessions and their meaning for the children working there. Ask children to journal about their ArtBreak work experience and reflect on their words. Cultivate a sense of positive expectation for the creative and relational work that will unfold in each ArtBreak session.

Reference: Carl R. Rogers, Freedom to Learn (Columbus, OH: Charles E. Merrill Publishing, 1969).

Example: When children in an ArtBreak group, carried away in their enthusiasm for finishing their work, simply could not stop in time to clean up and ended up leaving paint, cardboard, tools, and lots of other materials strewn about the studio, I was dismayed and exasperated at having to spend forty minutes tidying up the room. Indignant, I photographed the studio in its disarray. My first thoughts were of revenge: "I will close the cardboard section next week, and probably the paint section too!" After some reflection, I came to the thought that the students were actually excited to be in the studio again after weeks of snow days and had also probably forgotten about our routines. For our next session I sat down with the children at a table, showed them the photographs on my phone, and explained that it took me a lot of time to tidy up and was therefore not able to finish some of my other work that day. I asked them what we could do to make sure we clean up together and within our time limits. The children suggested they would pay more attention if I paired my cleanup announcement with dimming the lights. We proceeded with the session, and I was pleasantly surprised at the rush to clean up at the end that left the studio clean enough for me to get on with the rest of the day.

Prizing the Learner

Prizing the learner involves what Rogers calls a non-possessive caring, a belief that the child is fundamentally trustworthy.

Example: I keep in a file drawer two "teacher tools" for cardboard work: an awl and a craft knife, usually an Olfa utility blade. Both are quite strong and sharp. I am careful to keep them in my pocket and not leave them about. One morning I could not find the awl and, because the group included a couple of boys considered "behavioral problems," I found myself wondering and worrying if one of the two had pocketed the tool. Unable to find it, I finally spoke and said that I could not find the awl. One of the "behavioral problems" stood up, looked around, and pointed to my desk — "It's over there." Exactly where I had left it. I felt abashed to

have suspected the children and resolved to trust them and be more mindful of my own actions.

Rogers writes of having trust in the constructive tendency of both individual and group. He explains "Students who are in real contact with problems that are relevant to them wish to learn, want to grow, seek to discover, endeavor to master, desire to create, move toward self-discipline. The teacher is attempting to develop a quality of climate in the classroom and a quality of personal relationship with students that will permit these natural tendencies to come to their fruition." (See Carl R. Rogers, *The Carl Rogers Reader*, 313.) I try to model and show by my words, actions, placement of objects, and care and use of materials what is valued: that the children's work is important, worthy of both my time and their care. Even when a child destroys his work there is an opportunity to acknowledge his feelings and process. A six-year-old became frustrated with her project, a police uniform—in her words, "a cop suit"—as it was not turning out with the authenticity and authority that she had hoped for. She suddenly and dramatically tore it up, stomped on it, and stuffed it in the trash can. The other children turned straight to me for my reaction. My first impulse was to cry, "No!" but I managed to stop myself and remarked to the group, "Making art can be frustrating sometimes," then sat down to talk with the child to help us both understand her frustration.

Prizing also involves encouraging and valuing the choices and opinions of the child, accepting choices as givens and trusting that a child will try and discover. I have yet to see a child who, with encouragement, does not rise to the opportunity to choose his or her own work in ArtBreak. When we give attention and respect to a child's decisions and choices she learns that her work is important.

Giving quiet attention as an observer and helper confirms the importance of a child's decisions, so that the choice of this red feather or that orange one, the search for just the right button or bead, a found length of silver cord or blue lace, the choice of whether to build or paint, all become a matter of thoughtful contemplation.

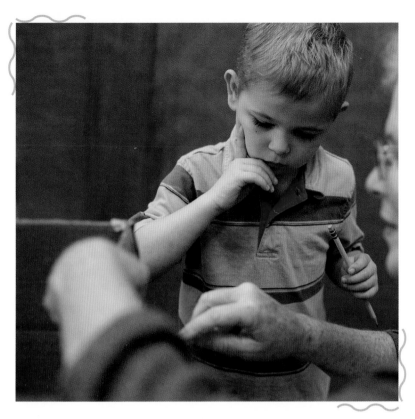

When we give time and attention to a child's decisions and choices, he learns that his work is important. This child is deciding where the facilitator should cut his cardboard. *Photo by Josh Birnbaum*

Our questions and statements (both directive and reflective) show that we take a child's choices and intentions seriously and that we are offering choice and control.

"You would like to paint today? Would you like to paint with your hands or with a brush?"

"Draw a line where you would like me to cut the cardboard for you."

"OK, so you are needing something to make the brain for your robot."

Children understand their ability to choose their work in Art-Break and will occasionally correct well-meaning adults who give a casually directive remark. During one of our summer programs a seven-year-old told her parent on arrival, "I'm going to finger-paint again." Her parent remarked, "Oh, you'll probably be doing something different this time." "No," said the child. "We get to do *whatever* we want to do." If a child seems stumped about what to make and asks for help with a remark like, "I don't know what to make today," a helpful prompt could be, "What have you been thinking about making?" or "Is there something you have seen that you would like to try?" To a child who once asked, "Is there anything new today?" I had to reply, "No," and wonder how this child, who usually constructed sculptures, would respond. No worries: "Well, I guess I'll paint since I haven't painted yet."

Responding to a finished work is an opportunity to reinforce process and choice. When presented with a finished work by children, I try to avoid evaluative statements praising the product and offer, instead, a comment showing that I value their work and treat their art making seriously. One simple way to respond is to describe what you see or what you notice. Examples: "You had to combine colors to make that orange." "That (a picture) looks like an exciting place to be." "You really did a lot of problem solving to build this." "That took a lot of attention to details." "How can I help you get this safely home?" "I notice you have painted your whole family on the box." "That sky reminds me of a cold winter night." Encourage children without uttering the words, "I *like* your (colors, drawing, painting, etc.)," by choosing words like "I notice," "I am feeling," "I see that," and "What do you think/need?" so that children are encouraged to pursue their interests with care, purpose, and consideration for their work and for the group, rather than to please and obey the facilitator.

You can also encourage and model appropriate comments from the children. Sometimes we have time for an impromptu "critique" at the end of a session, and I ask if anyone would like a comment, reflection, or question from others about their work. If you have modeled clear and supportive language, the children will come

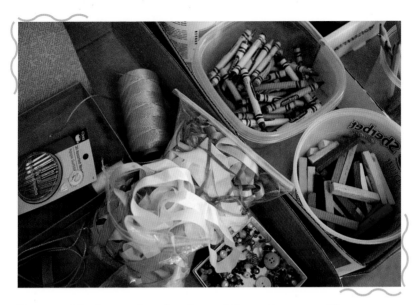

From a wealth of materials an abundance of diverse ideas grows. *Photo by Josh Birnbaum*

through with the same. I have learned not to ask questions like, "What's this?" and "Why is this here?" as they are not helpful to children. I once asked a boy a question about what he had done and he responded, "I do not deal so much in questions."

When children infuse their art making with other activities, you can observe and let it happen, as in my notes on the work of two five-year-old girls: "Sherry and Violet danced to the Modern Jazz Quartet CD playing today, painted together, and then made little cards with colored pencil drawings. Next they got under the work-table and talked."

Let children determine content for their work, even if it is more repetitive than you like. When a ten-year-old boy, who was sure that he could not draw, made a booklet, filled it with detailed drawings of professional basketball players, then made and filled another one, I thought it was a lot of basketball and was glad he had burst into drawing.

Problem solving is a big part of making art. Support children's efforts rather than solve problems for them—prize their ability to solve problems creatively. I am often asked by adults if it is ever appropriate to step in and show a child how to do something. The answer is: *certainly*. This can be done regularly in ArtBreak when introducing new tools, materials, or techniques at the beginning of a session. Educators know this as scaffolding: showing students how something is done, giving them an example of the finished product or model, pausing for reactions to the new material technique or material, and reviewing when needed. The session plans in the resources section and chapter 3, "Supplies and How to Use Them," give many examples of this.

I am not especially talented in solving spatial and construction problems but I know I can help children accomplish what they have in mind, and finding an expert is sometimes the right solution. Once a child began building a box to hold mementos about his beloved father, and he felt he needed a sturdy closing mechanism. He tried a few things, but we were both stumped. One of our school-district maintenance and construction employees happened to be in the building, so we sought his help. This man patiently showed us a handy way to make a good fastener with nothing more than a button, a piece of string, and a brass brad; the problem was solved, the box holding its treasured memories secured, and both the child and I learned a new skill.

Prizing involves consideration of diversity, or bringing strategies of cultural sensitivity so that a facilitator is able to provide an environment that is culturally relevant, developmentally appropriate, accessible, and gender responsive—one that reflects the understanding that children's creativity is part of who they are and what they bring to art making. All children, whether they are from backgrounds of plenty or poverty, value a wealth of materials. And from this an abundance of diverse ideas grows.

Children will plunge into a well-stocked basket of fabric remnants, holding up with speculation a bit of fabric to evaluate its suitability for their particular purpose—a bed for a kitty, a pillow for

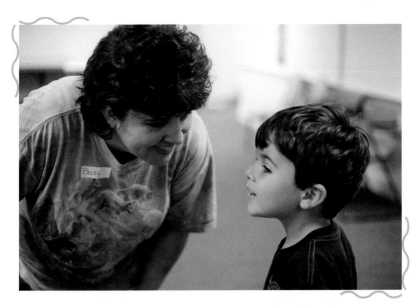

Children respond to empathic understanding. *Photo by Josh Birnbaum*

a cousin, an apron for Mom, a curtain for a dollhouse, a felt mask. "Could we have clay for this?" they ask, "Can you get us some wire?" "How about some googly eyes?" and "Might we learn how to knit?" A patriotic child announces, "We need a flag for our studio," and paints one. A child from a family of quilters asks for help piecing a quilt for a new baby. A child with a Native American heritage sings a lament for us and paints a picture of displacement from tribal lands, a story handed down by his family. A girl who is adopted talks about her experience. A child's drawing of an octopus prompts a lively discussion of which is better to eat, squid or octopus, to the amazement of the children who had never thought of eating such things. A quiet boy begins to talk after a few sessions and shared that he had visited a zoo and seen a reindeer; the others were excited and asked if it could fly. A kindergartener spent months absorbed in painting many-colored boxes; his mother felt this work helped him heal from the death of his father, who was an artist. A discussion of ghosts, started by the children, elicited several family ghost stories

and a critical analysis of whether ghosts are real. A girl built a "booby trap" for the mice in her home, prompting a discussion of why one might have a mouse in the house.

What all children in the groups have in common is engagement in art making. As they work, their selection of materials and projects helps them achieve balance as they integrate relaxation, participation in a social community, and problem solving. Occasionally they are inspired to reflect on the role of art making in their lives, like a third-grade girl who announced to the group: "I feel happy when I think of ArtBreak. I love ArtBreak. I think I can be an artist." The other children nodded and made sounds of agreement. As she built a cardboard and fabric model of an art studio, she mused, "I never thought that I could be an artist."

Much of my ArtBreak work has taken place in rural Appalachia where many families are deeply embedded in a beautiful natural landscape that offers limited opportunity for paid employment. Some families supplement their incomes by gardening and raising livestock and rely on a culture of thrift and a network of extended family for support. A very few engage in illegal activities, including theft. I have learned that certain materials, like copper wire and aluminum cans, are "loaded" with financial and personal meaning, thus expanding my worldview about materials and how one might regard them. Copper is valuable; a very few children have experienced being stationed by their families as "lookouts" while the adults take copper tubing from construction sites. Therefore, even a small coil of thin copper wire in the studio can excite feelings that may be difficult for some children to process. Aluminum cans, on the other hand, once inspired a lively discussion at lunchtime. I had taken my sandwich and a can of V-8 juice to a picnic table on the playground, where half a dozen children joined me. One picked up my empty can and said thoughtfully, "You know, this is a valuable thing." The children discussed the prices of recycled aluminum, shared stories of the local junk yard, and told me how I might earn extra money by saving my cans and taking them to a recycling center that would purchase them.

Following are questions you might ask yourself in order to create a culture of self-awareness, reflection, and mindfulness with regard to the cultural diversity of the children you serve. They are developed from the discussions and questions in Paula Howie, Sangeeta Prasad, and Jennie Kristel's book, *Using Art Therapy with Diverse Populations: Crossing Cultures and Abilities*. Another fine, detailed resource is Derald Wing Sue and David Sue's *Counseling the Culturally Diverse: Theory and Practice*. Written for counselors, this volume will support anyone working in education who wishes to develop multicultural competence.

Self-awareness

- Who am I as a cultural being?
- Where am I in regard to my own racial/cultural identity development?
- How might I be prejudiced?
- Am I being racist? Am I aware of/can I recognize micro-aggressions that may affect a child or exist within the ArtBreak group?
- How do I perceive the role of disability as a cultural identity?
- What perceptions and/or stereotypes do I hold in regard to poverty?
- What privilege, power, or control do I have because of my culture or ethnicity?
- What culture-bound, class-driven, and/or language variables are part of my cultural heritage and customs?

Knowledge

- What questions can I ask to better culturally attune myself to the needs of a child in my ArtBreak studio?
- What personal and cultural lenses might affect a child's perception of the meaning of different colors?
- What family values do the children hold? What kind of relationships do they value—egalitarian, formal, informal/relaxed, personal?
- What experiences with racism and discrimination have the children had?

- Is there a spiritual or religious dimension to consider for me or for the children?
- Am I able to notice how the worldviews of children in the studio influence their art making and their social interactions?

Skill

- Do I know where to obtain consultation for adapting the ArtBreak environment to the needs of a child with a disability? School counselors, school psychologists, special education teachers, and school occupational therapists can be of assistance and can also put you in touch with community resources.
- How does my self-awareness inform my practice as an ArtBreak facilitator?
- Likewise, how does my knowledge of the culture and worldview of the children inform my work in facilitating their work in the studio?

Empathic Understanding

In schools we excel at evaluating children, their accomplishments, and their capabilities. Empathic understanding is created when we try, rather, to understand a child's experience, to stand in his or her shoes rather than to engage in judging and evaluating. This can mean noticing how a child seems to be feeling. One morning a second grader entered the studio and picked up a collage on which she had been working. After a while I noticed she seemed half-hearted in her efforts, letting materials fall through her hands and propping her head up with her hand. I wondered why she was not busy with her work and, watching for a moment, guessed that she was tired or maybe stressed and asked if she would rather paint to-day. The child nodded gratefully and was soon absorbed in the color and relaxing flow of finger paint.

One way to enter into the experience of children in ArtBreak is to ask them to keep journals and then, as facilitator, to spend time

reading and absorbing their content. I have made simple journals (half sheets of standard copy paper, stapled on the short side with cardstock cover) and asked children to answer four questions in them at the end of each session:

1. What did you make?
2. What materials did you use?
3. How do you feel?
4. What are you thinking about?

Scribe for children who need it—they are "authoring" and you are simply getting their thoughts down. These examples show four journal entries followed by my notes (in italics). I used an interpretive process of working to understand the children's experience through writing a memo to myself for each of their entries.

Today I used sticks, cardboard, and tape—sticky duct tape—and I used the little small sticks, glue, I used all this to make a house. Also the glue to stick them on. I got great ideas, huh! Cause in our group we're all good at working.
 I feel happy.
I am thinking about my papaw—he died. The ambulance had to pick him. Because he had cancer. He couldn't breathe. We had to bury him in the ground and I cried.

This child uses a density and richness of many materials to build things. He arranges and glues to make a house. He is pleased with his ideas and sees all in the group, including himself, as good at doing their work. He is happy. The death of his papaw is also much on his mind. He died the previous year, and he was sad.

Today I painted the dragon. [I keep in the studio as an informal "mascot" a colorful Playmobil® dragon.] I used paint and paper. It felt good. I am thinking about dragons.

As this child comes to know a dragon by painting it, the image becomes a part of her consciousness and she reflects on it, pondering dragons as an idea or, maybe, as a reality rather than as the plastic toy in front of her.

I made a person and an escape pod. I used a plastic Easter egg-shell and a wood peg. I felt great. I am thinking about space.

This boy constructed, with a plastic Easter egg, a vehicle for space travel and, in doing so, began to contemplate space in general. He has moved from the particular to the vast concept of space, and the process—planning, constructing, and expanding his thoughts—makes him feel very fine.

I made a car for my little brother. I used cardboard. I felt good. I am thinking about my little brother driving his car.

This child thought to build a toy car for his baby brother and felt happy about doing so. There in the studio at school he is imagining his brother playing with the car.

Finally, to genuinely exhibit realness, prizing, and empathic understanding requires that a facilitator undertake what Rogers calls *living the uncertainty of discovery*. If, like me, you have some trepidation in letting go of control and power and giving responsible freedom to children, if you feel it is risky to allow children to choose their own work, if it feels a little uncomfortable to create a climate that allows all kinds of feelings, if you are not quite prepared to take such risks—take courage. If you offer just some modest amount of these three qualities—realness, prizing, and empathic understanding—you will see that children will respond constructively and take hold of their own experience and learning.

EXPRESSIVE THERAPIES CONTINUUM

Introduced by Vija Lusebrink and Sandra Kagin in 1978, the expressive therapies continuum is a theoretical framework from art therapy. Art therapist and scholar Visa Lusebrink has researched and written deeply for decades on the topic. To honor the third decade of Lusebrink's work, Lisa Hinz wrote an entire book, *Expressive Therapies Continuum: A Framework for Using Art in Therapy*, on the expressive therapies continuum. ArtBreak draws on a basic part of the ETC framework: the levels and functions of art materi-

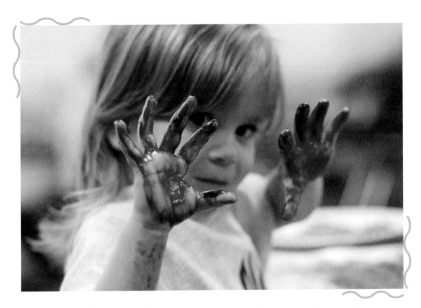

Finger paint, the most fluid of media, supports relaxation and expression of feelings. *Photo by Josh Birnbaum*

als. The ETC delineates three levels, or functions, of art materials related to their degree of fluidity and resistiveness. Fluid media, like watercolor and finger paint, support kinesthetic and sensory goals like relaxation and expression of feelings. More resistive media, like tempera paint, colored pencils, crayons, and other drawing materials, support perceptual and affective goals such as identifying feelings, improving social understanding, understanding cause and effect, and creating narratives. Highly resistive media, like collage, sculpture/construction, and other art making involving two or more steps, develop problem-solving skills and help the art maker identify and integrate strengths. Table 2.2 charts the levels and give examples.

Simply restated, the ETC outlines three areas of therapeutic and educational goals that can be addressed with art making:

1. Fluid media such as watercolor and finger paint support
 sensory goals such as relaxation and expression of feelings.

Table 2.2. The Expressive Therapies Continuum in ArtBreak

Continuum Level	Brain Structure and Function	Goals	Supporting Materials
I. Kinesthetic/Sensory	Basal ganglia, primary motor cortex Simple motor and visual function	Relax Express feelings	Soft clay Finger paint Watercolors Chalk pastels Torn paper

ArtBreak example: Too tired to work. A child came to the group looking tired and listless, her head in her hands. She put aside her collage and asked to finger paint. In a few minutes she was refreshed and able to return to the cognitive tasks required for her collage.

II. Perceptual/Affective	Amygdala (processing feelings) Ventral stream (identifying objects) Differentiating and identifying forms Expressing feelings	Improve cognition Empathic understanding Identify feelings Improve social skills Improve attention Understand cause and effect	Tempera paint Acrylic paint Crayons Oil pastels Drawing materials Graphite

ArtBreak example: How I look when I feel angry. A child who struggled with managing his angry response to frustration paused in a tricky part of constructing a bridge with popsicle sticks to make an expressive clay figure. He explained to the group that this was how he looks when he gets angry and returned to his bridge work.

III. Cognitive/Symbolic	Problem solving Pre-frontal cortex	Develop problem-solving abilities Identify and integrate strengths	Collage Sculpture/construction w/repurposed materials Clay Mask making Markers Art making with two or more steps Illustrated books, narratives, maps, instructions Sewing

ArtBreak example: How do you make the robot stand? Much problem solving is required to build a robot of repurposed materials that will stand up. Choosing or building legs of particular heights and weights and attaching them firmly requires problem solving, mathematical calculations, estimations, exact measurements, and careful cutting.

References: Lisa Hinz, *Expressive Therapies Continuum: A Framework for Using Art in Therapy* (New York: Routledge, 2009); Vija B. Lusebrink, "Assessment and Therapeutic Application of the Expressive Therapies Continuum: Implications for Brain Structures and Functions," *Art Therapy: Journal of the American Art Therapy Association* 27, no. 1 (2010): 168–77; Katherine Ziff, Lori Pierce, Susan Johanson, and Margaret King, "ArtBreak: A Creative Group Counseling Program for Children," *Journal of Creativity in Mental Health* 7 (2012): 108–20.

Resistive media like construction materials develop problem-solving skills.
This child has created a cardboard vehicle. *Photo by Josh Birnbaum*

2. More resistive media like color pencils and crayons address
 affective goals like increasing empathic understanding, un-
 derstanding cause and effect, and building social skills.
3. Resistive media such as collage, constructing, and sculpting
 develop problem-solving skills, integrate strengths, and sup-
 port creative thinking. (Katherine Ziff, Lori Pierce, Susan
 Johanson and Margaret King, "ArtBreak: A Creative Group
 Counseling Program for Children," in *Journal of Creativity
 and Mental Health* 7, no. 1, 2012.)

The framework is a useful guide for (1) selecting media for the
ArtBreak studio; (2) identifying referral goals for children; (3) re-
flecting on their work; and (4) referencing in documentation. The
ETC in the studio brings a natural balance to children in the studio
as offering materials from all three levels gives them access to relax-
ation, community, imagination, and problem solving.

Lusebrink has recently identified brain structures and functions
underlying the three levels of the ETC. The kinesthetic/sensory

level, with its simple motor and visual functions, appears to reflect the involvement of the basal ganglia and the primary motor cortex; the perceptive/affective level, involved with the process of differentiating and identifying forms and expressing affect, appears to reflect the work of the amygdala in processing feelings as well as the ventral stream which works to identify objects; the cognitive/symbolic level, involved with processes such as problem solving, reflects the work of the prefrontal cortex. Table 2 shows the three ETC levels and the associated brain structure; it also gives an example of each of the three levels.

The work of one student, Shira, over the course of a school year provides an unusually clear example of movement along the expressive therapies continuum. Shira was referred to an ArtBreak group because her teacher and her mother felt the experience would support development of social skills—she was considered shy. Each student in her group began by building a sketchbook in which to work; students chose papers for the interior and personalized their covers. Shira designed and built a book dedicated to portrayal of sea creatures, and her drawings were expressive, colorful, and full of movement. For weeks Shira filled her book with images of sea creatures using soft pastels, a very fluid medium. An orange octopus swam in a sea of blue pastels, and whales cavorted beneath the waves. Shira began her work very much absorbed in her flowing pastel drawings. She sat apart from the group, by herself at a side table, using her hands to spread the soft color over the pages. The other children observed out loud: "She likes to draw sea animals." After a few weeks her whales began to leap to the surface of the sea under a yellow sun, and a submarine (periscope up) rose above the waves; for these drawings she used crayon and water-based markers, more resistive media producing stronger, more defined edges. She began to talk a little to the group about the creatures, naming them, and, in the case of a black lantern fish executed in marker, describing its habitat. This drawing inspired an animated group discussion about fish; as a result, two other children decided to produce fish drawings, too. Shira had moved from the kinesthetic expressiveness

and dreamy chalk pastels of ETC Level I to engaging in social relationships, a feature of Level II, while making drawings with crayon and marker. At this point, she had filled the pages of her sea-creatures book and built a new, smaller book that she filled with graphite drawings of dinosaurs. I reflected to myself that she had begun under the sea, working by herself with chalk pastels, and progressed to submarines and whales above the surface of the water executed in crayon and marker, and then to dinosaurs walking about on dry land with details carefully drawn with graphite. As she worked with more resistive materials (crayons and markers) she began to talk with the other children in the group. Then Shira chose to sit at the large worktable with the other children and begin a 3D sculpture of a whale—she had moved to ETC Level III and was using repurposed materials to design and construct the creature. As she chose and worked with her materials (cardboard, brass fasteners, a large plastic yogurt cup, two large eyes of green paper, and duct tape), she moved around the room gathering tools, consulted with others about materials and methods, and went with other students to the hallway table to gather items from the sculpture center. By this time Shira had revealed her sense of humor, contributing to group sessions a few jokes and making wry observations about the work of other students. She had quite naturally, through her art making within the group setting, integrated relaxation with cognitive development to become more socially comfortable with other children.

Other considerations related to the ETC are mediators, limits, and complexity. *Mediators* are tools that provide actual distance as well as psychological space between the artist and her materials; this space allows for reflection rather than immediate sensation and reaction. Paintbrushes, for example, allow consideration of topic and actions in a painting. Finger paint, accomplished with the hands, allows for greater immediacy. *Limits* as to volume create different art-making experiences. A tablespoon of paint, a small jar of beads, and three kinds of ribbons allow just a few choices and possibilities, whereas a jar of paint, a big bowl of beads, and a large bin of ribbons and strings support many choices that may be overwhelming

The joy of the possibilities offered by big boxes also requires children to negotiate resources and weigh different ideas as they work out a group project. *Photo by Josh Birnbaum*

to some and exciting to others. *Complexity* relates to the number of art-making steps and materials a child proposes to use. More steps and materials generally require more cognitive processes. They present questions like the following: "Should I paint first and then apply tape or should I put the paint down first?" "What must I consider if I want to make a wearable table?" "What is required to make a quilt?"

A strand of creativity runs through all three levels of the ETC. We must, though, distinguish between what has been called "little c" and "Big C" creativity. Big-C refers to the adult ability to master a domain or field of activity and from that mastery introduce transformative change. For example, Big-C creativity resulted in the Nobel Prizes given to Jane Addams for her work connecting social work and a campaign for world peace, to William Butler Yeats for developing a personal literary style expressing Irish nationalism, and to Martin Luther King Jr. for bringing Gandhi's principle of nonviolent protest to flower in America. Little-c creativity refers to the everyday process of learning to solve a problem on one's own or to solve a problem in an unusual or non-standard way.

A self-directed art-studio experience such as ArtBreak allows children the freedom to engage in creativity. Here are two examples of children combining materials to create entirely new objects—a toy and a window-frame—from a box of cardboard materials. A third-grade student had the idea to make a robot. Working with very little assistance, he selected materials (a small box, a plastic yogurt container, cardboard, scissors, brass fasteners, and tapes) and set to work. In twenty minutes he had used these very ordinary items to create what he called a robot, and a very endearing one with movable arms, legs, and hands. The other children put down their work and exclaimed over the ingenuity and creativity of its maker, thus beginning a month of robot making by children eager to make their own robots. A first grader picked up a sheet of cardboard packing material with a pre-cut hole and pondered what it might become. As she began painting it pink, she decided to make a window, cutting, painting, and attaching other cardboard pieces as ornamental features, thus creating her own unique frame for viewing the world.

When we ask children how they decide what to make, they often mention that they see something that gives them an idea. One boy, noticing an oatmeal box in the supply bin, decided to make a drum, and his idea grew into a wearable percussion set. A third grader wanted a realistic image of his school, a "real picture." He lived across the street from the school and wanted to capture the view that he saw each day. So we photographed the school with a phone camera and printed the photographs; he cut and pasted them into place, then embellished them with watercolor, adding a brilliant blue sky and a green field in front.

DEVELOPMENTAL STAGES OF GROUP COUNSELING

In ArtBreak we rely on an "old standby" of group counseling as a reminder of what to expect in terms of group process: psychologist Bruce Tuckman's stages of group process. Although the stages follow the linear life of a group, it is helpful to view them as possibilities at any time. Sam Gladding summarizes in one of his texts, *Counseling: A Comprehensive Profession*, the characteristics of each stage, which are now known as Forming, Storming, Norming, Performing/Working, and Mourning/Termination. The forming stage features caution and hesitation with new experiences; storming features conflict, anxiety, and concerns about power; and norming is a time of feelings of belonging to the group featuring cooperation and collaboration. The performing/working stage features a focus on achieving individual and group goals with the group working as a productive system. At this point, children have become comfortable chatting with each other while they work and may sometimes bring up difficult topics. Late one afternoon three children sat working at the back table in the ArtBreak studio. I overheard two of them talking about how their therapist had left the clinic they visit and wondering who their new one would be. At this, the third child contributed that his cousin "some way hanged his self" over the weekend. Before I could make a remark about the death, the children moved on to discuss-

ing school; I made a mental note to talk privately with the child about the loss of his cousin.

Mourning, or termination, may feature reflection on the group experience, feelings of caring and compassion as well as sorrow, and sometimes an almost-frantic work pace. Table 2.3 integrates these stages with ArtBreak: what to expect and how to support the group at each stage.

The following session illustrates a group of upper-elementary boys who are moving from the storming to the norming stage. Here they are learning how to deal with limited resources and beginning to support each other as they all elect to undertake sewing projects. (This account is used with permission from the *Journal of Creativity in Mental Health*.)

> Six boys enter the room and walk around, examining the latest additions to the cardboard sculpture center and plunging their hands into the giant bowl of buttons. The counselor points out a shelf newly stocked with fabric, and there are exclamations. The boys have been anxious to sew for two weeks, ever since one of them fashioned large pieces of fleece scraps into a blanket for his teacher. Deciding to work on fabric projects, they rummage through wool remnants, flannel yardage, cotton batting, threads, and needles, bargaining with each other over who will get which choice lengths of fabric. They decide to make pillows of varying sizes, and chaos ensues with cries such as: "How do you thread the needle?" "How do I knot the thread?" "Someone help me straighten out my pillow?" "I need help! These scissors won't cut this material." "I asked first for help!" "No I did!" One boy has an outburst of impatience and retreats to the counselor's desk to re-cover, rejoining the sewing table after a few minutes with coaxing from another child. The counselor gives a brief demonstration of a running stitch (wishing she had purchased a heavier weight thread that would tangle less easily). Ten minutes of calm de-scend on the room, the boys carefully stitching. "I thought sew-ing was girly but it's not," one of them offers to the group. "We like this," a few boys reply. "So shorter stitches make the sewing stronger, don't they?" notes another student. "You know this is relaxing," declares the student who had the impatient outburst.

Table 2.3. Stages of an ArtBreak Group

Group Stage	What to Expect	Support to Provide
I. Forming	Questions about permission to use the art materials. At first children may ask, "May I use this?" They may find it hard to believe they have free access to all the materials.	Children will quickly learn they have full access if you assure them they may use the materials without asking and use language like "we" and "our studio."
II. Storming	Children may worry about finishing a project in one session. Expect conflict about who sits where, sharing tools and materials, who gets to use what.	Talk about the possibility of taking more than one session to complete a project and the frustration this may cause. Go back to the two studio rules, have a ninety-second meeting at the beginning of a session for reminders, questions, comments, and problem solving.
III. Norming	Children helping or offering to help each other, working in pairs on a single project, generating ideas for projects and new processes, requests for new materials needed.	Support ideas generated, obtain materials the children ask for when possible.
IV. Performing/ Working	Conversations about family, friendships, schools while working. A group may burst into a rendition of a song; a group may organize itself into collaboration on a project. Conversations may include difficult topics like abuse, rape, jail and prison, divorce.	Support group projects. A traumatized child may need individual help with boundaries concerning the disclosure of personal information.
V. Mourning/ Termination	Sadness and protest at thought of ArtBreak ending for the school year. Asking for more sessions or summer sessions. On the last day children can seem aimless and discouraged.	Begin talking about the last session a month before it happens. Create an ending, working with the group to plan it and make it happen. Make a slide show, create a book of what they have learned and advice/teaching for future ArtBreak groups, put up an art show.

Reference: Samuel T. Gladding, *Counseling: A Comprehensive Profession* (Upper Saddle River, NJ: Pearson, 2009). 264–66.

Then, another rush of calls for assistance occurs as the boys hurry to finish up their projects so they can take them home that day. A bag of polyester batting is passed around, and pillows of cotton flannel, calico, and fake fur ranging in size from six to eighteen inches long are stuffed, stitched, and tried out. One boy shouts with frustration about finding a way to bring his completed cardboard structure from the previous week safely home on the bus; another student comes to his aid, rummaging in the sculpture center for just the right size box. The boys rush back to their classrooms to get ready to go home for the day. The counselor sits down and thinks about how she might have created a more orderly introduction to sewing. The next day the school psychologist, after listening to an account of the sewing group, reflected that the session was a model for the boys in moving from chaos to calm productivity.

Two months later, the same group of boys has moved into the working stage. They are familiar with the materials and processes in the studio and have formed a working, collaborative community.

On this day a classmate drops by the group with his mother, the classmate in a wheelchair, his leg propped and encased in a large plaster cast. He has been out of school for several weeks, having undergone corrective surgery. The boys crowd around to say hello and one notices that the classmate's head is leaning against the wheelchair's metal head rest. A look of concern and compassion comes over his face and he exclaims, "Oh look, this is very hard for your head to lean against! You need something better, something soft for your head!" He looks up, gazes at the sewing cabinet for a moment and cries out, "Come on, we will make you a pillow!" Immediately all six boys fall in with the plan. They get out fabric for him to try and settle on a length of soft cotton flannel. Next they decide on a size, measure the fabric, and cut out the pillow. Parceling out the next tasks, they pin the fabric together, choose and thread a needle, and take turns stitching around the edges carefully leaving a gap. Next comes the fun part: stuffing the pillow. A couple of boys plunge their hands into the box of polyester fiberfill and pull out handfuls for another to stuff into the pillow. They have their classmate test it, add a little more fiberfill, and finally stitch the pillow closed. Voila, a comfortable

headrest! Classmate and Mom roll beaming out of the room and the boys in the group, in good spirits, clean up the studio.

I sometimes feel very much drawn to make art alongside the children, but find that, as facilitator, this compromises my ability to keep my attention on the group's process and the needs of individuals regarding the production of art. The facilitator also has to

- Model problem solving
- Demonstrate use and care of art materials
- Teach skills, in an effort to provide scaffolding, or a boost in problem solving that can lead to a new level of skill or understanding
- Encourage and model supportive behavior and language
- Keep time
- Document student-work products and the group's process
- Make decisions about introducing new materials
- Provide feedback to teachers, families, and others

It is the facilitator's job to support the group's process, create a child-centered environment, and offer art materials through the organizing principle of the expressive therapies continuum. Through this an ArtBreak group is able to reach a natural balance of work, helping, imagination, and community.

PART II

MATERIALS, SPACE & PROCEDURES

Materials and Tools

"Mixing colors . . . it is fun.
I learned that I like painting."

—*Second Grader*

THIS CHAPTER is a guide to materials and tools for an ArtBreak studio. The first part gives suggestions for what you'll want to have on hand for six art processes: drawing, painting, collage, print-making, sculpture/construction (including sewing), and embellishing. It includes lists of basics, suggestions for add-ons, and exercises for acquainting yourself with the materials and then introducing them to children. The second section recommends tools for six functions: cutting, fastening, measuring, sewing, sharpening, and cleaning. The resources section of this book has checklists to use in acquiring materials and tools and a list of resources for developing your own skills. Resist the urge, though, to go to Pinterest and find fully developed projects to offer children. ArtBreak is choice-based, with project ideas coming from their makers.

Start your program with a few basics (tempera paint, finger paint, crayons, colored pencils and markers, and papers will do fine) and add materials as you go along. Introduce new materials, gifts to

the studio, and new processes at the beginning of a session, taking a few minutes to show the process and its possibilities. The practice exercises in this chapter and the session plans at the end of the book will support you as you add new resources to your studio.

Many of the things you need can be obtained for little or nothing at yard sales and thrift stores. Let people know you will accept donations if they are cleaning or de-cluttering their homes, studios, and classrooms, and you can collect free cardboard boxes and other repurposed items from stores, homes, and school recycling bins. At the end of this chapter is a sample note to colleagues and friends asking for throw-away or extra materials that you can re-purpose in ArtBreak. Dress up this template with a photo of ArtBreak work, or a logo for your ArtBreak studio created from a child's drawing. You will need to buy some materials from art suppliers, hardware and home stores, and craft/fabric shops. Buy the best scissors, paint, paintbrushes, and pencils you can afford, as they will perform better and last longer than cheaper items.

MATERIALS

Drawing Materials

Markers are a resistant medium, great for dotting, striping, and filling in outlines. Purchase water-soluble markers as permanent markers are made with solvents that are usually toxic. Water-soluble markers wash from the skin, though not necessarily from clothes. Offer medium- as well as fine-point markers if you can, and arrange them so they are accessible and appealing. I sort them into color families (warm, cool, black/brown/gray) and store them in large plastic yogurt tubs.

Pencils are a resistive medium for drawing and writing. We keep a cup of standard #2B name-brand pencils like Ticonderoga or Blackwing on the studio table. I occasionally splurge on a box of holographic silver #2 Ticonderogas to add cheer to the studio in the winter. Avoid store-brand or generic pencils as their erasers harden

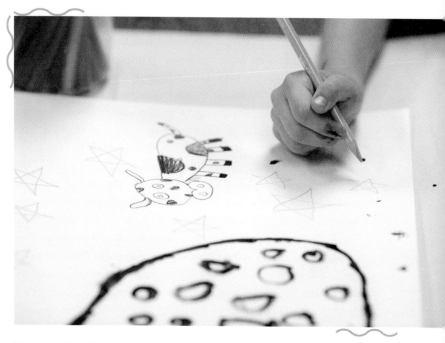

Pencils and markers are resistive media that are good for precision and detail. *Photo by Josh Birnbaum*

and become unusable, and they do not sharpen well. Avoid also pencils with festive paper or plastic coatings as they do not sharpen well, either. For more choice, add graphite artist pencils which come in various levels of "hardness" and provide a range of tones from light gray (the "harder" ones with a higher clay content designated by the letter H) to true black ("softer" pencils designated by the letter B). Artist pencils come without erasers and require that you keep white, pink, or gum or kneaded erasers handy. A *lead holder* with a fat stick of graphite is interesting and useful for drawing and marking cardboard.

Colored pencils come in a wide range of colors and can be used for drawing, coloring, and layering on a variety of surfaces including any kind of paper and cardboard. Look for a statement on the

box about nontoxicity. A box of thirty-six Crayola colored pencils works just fine; two boxes are even better. I keep them sharpened and loaded into three large plastic yogurt tubs, sorted by color family. For more choice, a collection of Prismacolor Premier soft color pencils, although somewhat expensive, offers a range of beautiful colors for drawing and coloring. Colored pencil marks can vary according to whether the pencil tips are very sharp or rounded from much coloring.

Crayons are magical sticks that announce "Time for fun!" One year at a national counseling conference I attended a variety of workshops, most of which featured PowerPoint presentations and note taking. Then I walked into art therapist Cathy Malchiodi's creative-counseling workshop and immediately felt happy and relaxed, for our places at the tables were set with fresh sheets of paper and crayons, promising (and delivering) an opportunity for meaningful play. Technically speaking, crayons are pigment mixed with a paraffin wax. They can be blended and are a less resistant medium than markers. Traditional school crayons are easy to use and come in so many colors. I prefer Crayolas and end up removing them from their boxes, then storing them in sectioned cafeteria trays or round plastic containers. In words attributed to Ru Paul: "Life is about using the whole box of crayons." So take them out of the box and make them accessible.

> *Practice exercise for marker, colored pencil, or crayon:* Choose a large sheet of plain paper and a crayon, marker, or colored pencil. For this exercise, marker flows most easily over the paper. Now, cover the page with scribbles. If you have chosen a large sheet of paper you will be able to use your whole arm to make sweeping scribble movements. Take a look at your drawing and see if you can find an image in the scribble, and from it make a picture. Then, give it a title. You can offer a game of "scribble chase" to a child who is reluctant to draw or do any kind of mark making, in which you begin drawing with a marker and encourage the child to chase your line with another marker, then vice versa.

Oil Pastels are sticks of pigment and chalk bound with oil and wax. They adhere to smooth surfaces, even glass and metal. You can build

up layers of oil pastel color that can be scored and scratched with the fingers, a straightened paper clip, or other tool. More fluid than crayons, they offer an intensity of color and thick layering possibilities.

> *Practice exercise:* You may remember this from your elementary-school art days. The technique is called *sgraffito*. Using one or more oil pastel crayons, lay down a smooth surface of color. Cover this surface with a darker or lighter color. Now, using a wire, paper clip, comb, or other object, scrape through the top layer to reveal the first surface color. You can create images and shapes in this way.

Chalk Pastels are a dry medium made of chalk, pigment, and a binding agent such as a plant-based gum. They are soft and expressive and are the least resistive drawing medium; they can be blended in painterly fashion with the fingers or a tissue. Pastel paper should have a bit of "tooth," or texture, for holding the medium; special pastel papers can be purchased but construction paper works just fine. Have a variety of colors of paper on which to work with pastels —a black background for instance offers a different look than a white one. Pastels break easily, but do not be dismayed by this. When introducing pastels to children I keep them in their original box to show off their beautiful glow, but soon they end up in a wooden box with other pastel sticks. You can demonstrate snapping the sticks in half to put children at ease about breaking them. Finished pastel artwork can be wrapped in tissue or newsprint to keep it from smearing and spreading the colorful dust. You can also purchase a milk-based, pump-spray fixative such as that manufactured by Spectrafix; the product is odorless but does contain grain alcohol so it should be stored securely.

> *Practice exercise:* Set out a box of pastels and paper. First try drawing lines, using the tip edge for thin lines and flat plane parts of the stick for thicker lines. You can fill in areas by cross-hatching or by repeated marking over the surface. You can build up color quickly by swooshing the whole side of a stick across your paper. Try making a smooth surface of color by smudging the lines of two colors with a paper tissue, cotton swab, or your fingers. Now, draw a six- to nine-inch circle outline on black or white construction

paper. Use a paper plate as a template if you like. This will become a mandala, a Sanskrit word loosely translated as circle. For this outline use a dark color on white paper or a white or other light pastel for the black paper. Now, fill the circle with designs and color of your choosing, using colors, shapes, and images as you like. Practice smudging and blending with fingers, tissues, or cotton swabs, and add a title. Blow excess dust away and finish with spray fixative.

Painting Materials

Children have fewer qualms than adults about seizing a paintbrush and setting to work with paint. Still, some need encouragement. Winston Churchill took up painting late in life and, although self-taught, became quite accomplished. Here is his account of his first encounter with the question of how to fill a blank canvas with paint, from his small book, *Painting as a Pastime:*

> Having bought colours, an easel, and a canvas, the next step was to begin. But what a step to take! The palette gleamed with beads of colour; fair and white rose the canvas; the empty brush hung poised . . . My hand seemed arrested by a silent veto. But after all the sky on this occasion was unquestionably blue, and a pale blue at that. There could be no doubt that blue paint mixed with white should be put on the top part of the canvas. One really does not need to have had an artist's training to see that. It is a starting-point open to all. So very gingerly I mixed a little blue paint on the palette with a very small brush, and then with infinite precaution made a mark about as big as a bean. . . . At that moment the loud approaching sound of a motorcar was heard in the drive. From this chariot there stepped swiftly and lightly none other than the gifted wife of Sir John Lavery. 'Painting! But what are you hesitating about? Let me have a brush—the big one.' Splash into the turpentine, wallop into the blue and the white, frantic flourish on the palette—clean no longer—and then several large, fierce strokes and slashes of blue on the absolutely cowering canvas. Anyone could see that it could not hit back. . . . The spell was broken. . . . I seized the largest brush and fell on my canvas with fury. I have never felt any awe of a canvas since.

So encourage children to dive fearlessly into painting. *Watercolors*, pigments dissolved in water, are familiar to most children. They are the most fluid of paints and have been used for millennia. These paints come in solid cakes of color in pans or boxes as well as in tubes and bottles, in both artist and student grades. Student-grade watercolors in pans are convenient. Children also love the liquid watercolors sold in bottles. Dilute these liquid colors by pouring a small amount into a lidded jar or plastic container and add water. You can save these diluted mixtures until the colors become muddy with mixing. Get the best watercolor brushes you can afford; they will last. Have a few flat ones and a few round ones, in small and large (one-inch) sizes. I keep the studio's watercolor brushes apart from other brushes so they do not get loaded up with acrylic or school paint.

Art papers come in weights indicated by a pound (lb.) number. Multimedia, or mixed media-paper, is great to have on hand as it is one size fits all: it will accept marker and pencil as well as wet media like watercolors and school paint. Canson offers an XL Mixed Media Paper, 98 lb., 12" × 18", in packs of one hundred. A pack (not pad) of white heavy-weight (60 lb. plus) drawing paper, 12" × 18", is a reasonable and inexpensive substitute. Although watercolors will work just fine on multimedia paper, papers specially made for watercolor have a texture and finish that accepts watercolor paint very beautifully. If you use watercolor paper, obtain it in at least an 80 lb. weight. Student- or economy-grade sheet packs of watercolor paper are much more convenient and cheaper than pads.

Dampen watercolor paper for an especially fluid and expressive experience. Pick up a few natural sponges (you can use regular sponges but the natural ones fascinate children) from an art-supply store and show students how to use them to wet the paper—enough water to provide a damp but not puddled surface. They can then apply pan watercolors with brushes or liquid watercolor with droppers. I mix up three or four colors of dropper bottles so children can blend them on the paper. I was reminded of the fluid, relaxing quality of watercolor one February when two boys spontaneously put aside their cardboard constructions and filled clear plastic egg cartons with

water, mixed in watercolors, and exclaimed over the delicate magenta, indigo, and yellow hues produced.

I could have used this idea one gray winter day when the Art-Break groups had been working furiously on cardboard construction projects. Feeling stressed by the tasks of supporting everyone with assistance and keeping the studio stocked with materials, I was moved to give us all, especially me, a break by cordoning off the construction corner of the studio for one session. The children were quite outdone with me and even reminisced at the end of the year, "Remember when you closed down the construction?!" Now in midwinter when everyone starts to feel super-busy, cramped, and weary of indoor recess, I bring out the dropper bottles of liquid watercolors, which have the effect of calming us all down and nourishing us with color.

> *Practice exercise:* Dampen a sheet of watercolor paper with a sponge. Choose two colors from a watercolor paint box and a one-inch watercolor brush—flat or round. Have a bowl of water for rinsing your brush. I like to use low, heavy, white ceramic soup bowls for this as they are stable and will not tip easily. The paint colors show up well in white. Wet your brush until it is soaking and take up as much of one color as you can from your pan and make a "wash" across the paper. If your paper is damp enough the color will bloom beautifully. Add your second color and observe how the two blend and spread. This can be a relaxing exercise.

Tempera or washable paint provides opaque coverage for paper and cardboard. I buy Crayola Washable Paint (sometimes called school paint) in sixteen-ounce, flip-top bottles in a variety of colors; unlike temperas they do not spoil over time and Crayola paints tend not to peel when dry. You can offer simply the primary colors (red, yellow, blue) plus black and white and let children mix colors on their own. Purple and magenta are also nice to have on hand. There are no "right" colors to use when painting or drawing. In the explanation attributed to artist Roy Lichenstein: "Color is crucial in painting, but it is very hard to talk about. There is almost nothing you can say

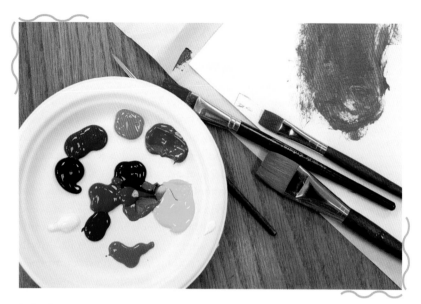

School paint comes in inviting colors. *Photo by Josh Birnbaum*

that holds up as a generalization, because it depends on too many factors: size, modulation, the rest of the field, a certain consistency that color has with forms, and the statement you're trying to make." So let the choice of color arise from within the maker of the art.

Washable paint cleans up with water but not always from clothes, so smocks are advisable. At the end of this chapter are instructions for making your own smocks from repurposed shirts. Offer a range of paintbrushes, round and flat in different sizes, buying the best you can afford, as they will last longer. Have a supply of foam brushes, available quite inexpensively from home and hardware stores, in different sizes. We keep a box of container lids to use for palettes on which to place and mix paint. Buy student- or economy-grade, mixed-media (wet and dry) white paper in bulk: mixed-media paper can be used for painting and drawing. You will want the large size, as you can cut it in half if smaller sheets are needed. Wood scraps can also be painted; if you keep a supply of small to medium-size

wood scraps in the studio, also have on hand sandpaper so the children can smooth the edges before painting. Be aware that the presence of wood will inspire ideas for projects requiring saws, hammers, and nails.

Having plenty of paint of whatever kind you choose allows children to work freely. That is not to say that anyone ought to prepare a big bowl of paint for painting on a small piece of paper, but you might well do so for painting a big cardboard box. I once took a watercolor class from painter and art professor Ron Kroutel who cheerfully scolded me for rationing out onto my palette a tiny dab of paint from my tube of Winsor & Newton indigo: "That is the most parsimonious use of paint I have ever seen!" So, in the words of artist John Sloan: "Don't be stingy with your paint, it isn't worth it." A little bit of teaching on this point is helpful, however. You can encourage children who use tiny dabs of paint to use all they need, and remind others to start with one good dollop and add more as they need it.

> *Practice exercise:* Gather three bottles of washable paint in three different colors, and bring them to your work area. Squeeze out dollops of each color on a plastic lid—one large lid or three small ones. This is your palette. Using whatever size brushes you please, paint on a large sheet of multimedia paper a story or event that you remember from your childhood. Or, paint a picture of a trip that you have taken. In one of the bottom corners, sign your name and add a title if you wish. In ArtBreak we usually sign with a #2 pencil, but you can use paint if you like.

Finger painting as we know it was originated by educator and artist Ruth Faison Shaw in 1929. She was inspired by one of her small pupils whom she had sent to the school bathroom to clean his cut finger with iodine; she found him there drawing on the bathroom tiles with the beautiful iodine color on his fingers. In 1931 she patented Shaw's Finger Paints. Today you can buy finger paint in plastic jars and bottles; I use Crayola sixteen-ounce bottles with the flip top. Its fluid, squishy consistency provides for some children a deeply satisfying tactile and expressive painting experience.

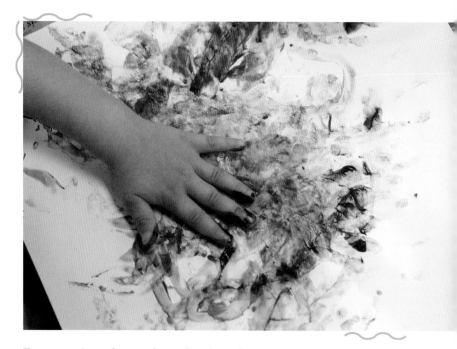

Finger paint's tactile appeal provides a kinesthetic experience. Use coated finger-paint paper that can be sponged with water for an even more fluid experience. *Photo by Josh Birnbaum*

You will want finger-paint paper, which has a shiny surface so the paint glides on very smoothly. I like to have the large paper size on hand—16" × 22"—so children will have plenty of freedom to paint. A few damp washcloths on the worktable will encourage children who are hesitant to plunge into finger painting for fear of getting their hands messy. Washable finger paint is easily wiped from tables and hands but can stain clothing, so again, smocks are advisable.

Finger paint is a very fluid and expressive medium. For some children who have endured trauma its expressiveness may bring up feelings of fear or grief, and its physical characteristics can be reminders of unpleasant experiences. It is therefore essential to respect children's inclinations to finger-paint or not. I make sure

children know it is available and leave it up to them to choose to use it or not. This possibility for tactile reminders of trauma is also true for clay. Sometimes, though, if a child is working on a complicated project and feels tired, complains of a headache, or seems to lack energy I propose a little finger paint as an alternative to the cognitive work of construction.

Practice exercise: Choose a color of finger paint and squeeze a large blob on a sheet of finger-paint paper. Dampening the paper first with a sponge is not essential but will give a more fluid experience. Have enough space around you so that you can relax and move your arms and shoulders as you paint. Then use one or both hands to spread and cover the paper with paint adding more paint as needed. Add another color if you like. If the paint begins to dry, sprinkle your paper with a little water. You can use your whole self—hands, wrists, sides and backs of your hands, nails, even your forearms to move the paint around on the paper and to create white lines or spaces. Experiment with "drawing" into the finger paint. If an idea comes to you to make a picture, in the words of finger-paint originator Ruth Faison Shaw: "Make the far away things first and the close-up last." Also in the words of Miss Shaw: "Always go about it naturally. Remember finger painting is a pleasure, not a chore!" When your painting is finished, place it on newspaper or cardboard to dry. If you want to smooth it out, you can iron it on the backside with a warm iron.

Acrylic paint dries fast and resembles oil paint in finished form. I buy liquid acrylics in bottles and offer them to children who indicate interest in creating finished paintings on canvas or boards, or if we are painting something like furniture and want a permanent finish, as washable paint may eventually peel. Acrylics also work well on wood.

Practice exercise: On a sheet of cardboard or a small scrap of wood use acrylics and brushes to paint an image of a dream that you have had. Practice covering larger areas using a foam brush, then adding details with a smaller brush.

A simple collage featuring school paint and buttons. *Photo by Josh Birnbaum*

Collage Materials

Collage is a process of gathering, cutting, and tearing materials and affixing them with glue to a surface like cardboard or paper. The process has multiple steps and generally requires a little planning. Children use collage in a number of ways, including: to tell stories, to explore interests, to present narratives about themselves or others, to celebrate occasions, to represent feelings, and to make something meaningful and beautiful for someone. Create a collage center by collecting lots of different kinds of repurposed papers. Artist Julian Schnabel, known for his collaged paintings, stated: "I work with things left over from other things." All kinds of things are suitable: magazines, calendars, greeting cards, catalogs, wrappers, tissue

papers, foil and metallic papers, fabrics, laces, maps, patterned papers, labels, various papers including trimming "ends" that collect around paper cutters, paper doilies, and interesting labels and tags. Keep them in boxes or bins; clear plastic bins allow children to see what is available. If you have a lot of magazines and catalogs keep them separately from your loose papers so as not to weigh down and obscure the loose items. Likewise, a collection of small tags and cards will show to better advantage if grouped together in a separate bin. Laces, strings, and other textile bits can go in another box. Even 3D objects like buttons and small metal objects can be collaged. A stack of cardboard to use for collage backing, glue sticks, and scissors, and you are set. I collect cardboard boxes, used tri-fold project board, and foam board sheets; cut them into standard sizes (9" × 12", or 6" × 6"), using a craft knife and a steel ruler; and stack them by the boxes of collage materials.

I had read that collage can generate a big mess but did not believe it until I tried it myself and then offered it to children, and, yes, it is true: paper cuttings and scraps fly everywhere but are a necessary part of the all-absorbing, cutting, tearing, choosing, and arranging-in-the-moment flow of the process. And by the way, I have offered collage to adults in workshops and the same joyous mess results. In experimenting with keeping collage papers into jumbled bins, rather than in organized theme folders, I noticed that children go for the jumbled bins every time. I think they enjoy the pleasure of rummaging and discovering just the right unexpected treasure.

> *Practice exercise:* Assemble a few magazines, catalogs, and odd bits of paper and fabric. Choose and then tear or cut out images, shapes, and colors that make you feel happy or represent a goal you would like to meet. Arrange these on a sheet of cardboard (small or large) and affix them with a glue stick. Layer and load your collage with images and textures as you like. Try to completely fill your cardboard; you can extend your materials beyond the cardboard edge if you like. If you paint over the collage with a clear matte acrylic medium, like the Golden or Utrecht brand

paints, or with clear Mod Podge, this treatment, when dry, allows you to embellish the collage with words, images, and highlights of chalk pastels, oil pastels, paints, or markers. Display it in a place where you can enjoy it.

Printmaking

We began simple printmaking in ArtBreak when a student asked for a potato so that he might carve a stamp. In February, we experimented with heart-shaped stamps cut from Styrofoam trays and glued to spools.

> *Practice exercise:* We also show children how to make a simple monotype print. Using washable school paint and a foam brush, apply a square of color to the surface of a worktable. Children can paint directly on a plastic or formica tabletop with this kind of paint, usually to their delight, or you can use trays or tinfoil. Using fingers, a craft stick, a comb, or another tool, make marks or create a design in the square of color. Now, gently float a sheet of multimedia paper on top of the paint square and smooth it with the hands or a soft rubber brayer (roller). Peel off the paper, and the print appears! Experiment with the right amount of paint: too much, and the paint will form a blob instead of picking up the design. School paint wipes clean from the tabletop with a damp cloth, even after it has dried.

Sculpture, Construction, and 3D Design Materials

To the master Michelangelo is attributed this quote about sculpture as discovery: "Every block of stone has a statue inside it and it is the task of the sculptor to discover it." In the ArtBreak studio this translates into the question, "What wants to be built today?" Collecting and constantly refreshing a rich and varied assortment of construction supplies makes this question easy for children to answer.

A *construction work station*, stored in a bin or a big trash bag or displayed on a shelf or under a table, can be stocked with found and

recycled materials such as cardboard sheets and tubes, boxes of all sizes, and clean plastic containers. We also stock beads, various yarns and strings, ribbons, laces, fabric bits, wire, buckles, zippers, and small, safe, metal objects like keys, chains, and parts of machines. If you make it known that you collect these things, people will think of you and bring them to your studio or classroom when they are cleaning and recycling in their homes, offices, and classrooms; the resources section of this book has a sample note asking for donated supplies. I also visit grocery stores and home- and office-supply stores to pick up cardboard containers of all types. You will want to constantly replenish your supply as, once children start building things, they will use a lot of material. Construction is a highly cognitive activity requiring envisioning, solving all kinds of problems, working over several weeks or even months, and using many materials and processes.

The only construction limitation I consider is size. Unless you can develop a relationship with an accommodating bus driver who has extra seats, if something must go home on a school bus, a child must be able to hold it on his or her lap. You can, though, make home deliveries of large sculptures or work with families to pick up an especially large piece like a life-size robot or playhouse.

Children practically explode into creative production when presented with construction opportunities and will make all kinds of things: toys, useful household and classroom items, homes for pets, wearable art, and costumes. Here is a partial list of things creatively constructed with cardboard in one of our school ArtBreak studios over the course of one year:

3D collage
Alien
Barbie box
Books
Box with a color plan
Camera case
Cardboard building with a wrecking ball

Cardboard panels painted and wired together
Device for catching mice and providing food and shelter to
the creature
Dog
Dollhouses
Gravestone (a prop for a show)
Hot rod
Hotel for moms
Hotels (double and attached, a collaboration between two
children)
House for a cat, with a chimney flap to keep out the rain
House for orphan puppies
House with a chimney
House with a porch and a glider
House with an ice-skating pond
Houses for pets: dogs, cats, gerbils, guinea pigs, baby kittens
Mansion to live in, with curtains
Musical instruments: wearable drum set, guitars, flute
Name signs for bedroom doors
One-eyed monster for my teacher
Painted cardboard mountain range
Painted cardboard spears
Painted storage box
Photo collage of school with shelf underneath
Planes and gliders
Racetracks
Rattle
Robots
School of the future with a roof that opens
Telescope
Valentine boxes
Wearable desk
Wearable robots
Wearable zebra nose
Yo-yos

Wrapping up a school year with one group that had been particularly engaged with cardboard construction, I reminded them that we had three more sessions and for one session I was planning to make cupcakes. Long silence from the children . . . and then: "Mrs. Ziff, will they be cardboard cupcakes or will we be able to eat them?"

Occasionally a child will undertake a project that, in its symbolism, supports recovery from trauma. A child who had survived a traumatic event involving water once worked for nearly a whole school year in ArtBreak constructing a sturdy and well-articulated waterproof structure. Without any direction, just support in what he was trying to make, this child was rebuilding a strong and resilient sense of self. In this instance, nonjudgmental and descriptive observations were all the commentary needed: "Your building is starting to take form." "Those walls look strong." Then, in response to a question about whether duct tape is waterproof, we tested the structure out in the sink and discovered that it provided a sufficient amount of water resistance.

> *Practice exercise:* Make a robot with movable arms and legs that will stand. While we show children ways to attach materials, it is not necessary to give them directions about how to choose parts and assemble them. I have found children to be much more inventive than I am in this regard. But for purposes of learning how to support children in their work, here is one way to make a robot: Choose two small to medium-size cardboard or plastic boxes or containers, one for a head and another for a body. You can use boxes, cardboard tubes, and thick, flat pieces of cardboard for arms and legs. Gather ways to attach or affix things: duct tape, hot glue, clear tape and brass fasteners. To the head box add any headgear you like: hats, hair, antlers, halos, beads, ears, and earrings. Before attaching the head, work with the body to add arms and legs. Brass fasteners, attached through holes that you punch with an awl, will allow arms to move. Test to make sure the robot stands. The larger the robot, the wider and sturdier the legs must be. Add any other ornament to the body that requires access to the inside of the box, such as a tail or cardboard wings. Now, attach the head to the body. If you use brass fasteners, you will need to leave access to

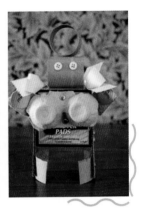

Robots made by the author and displayed alongside child-made robots at a public library exhibit. *Photos by Matthew Ziff*

the inside of both boxes so as to work with the fasteners. Paint or collage the surfaces as desired, adding eyes, a cape or other clothing, feet, buttons, signs, or jewelry.

Several of my own robots are pictured here. Seeing the children's robot creations was so exciting I had to make some of my own in my home studio.

Offer *mask making* later rather than earlier in a series of Art-Break sessions. Children can make and ornament cardboard and fabric masks. You can also purchase inexpensive plastic mask-forms and children can cover them with strips of plaster gauze, available from art-supply stores. The gauze is dipped in water and then applied to the mask form. When the masks dry they can be removed from the forms, painted and ornamented.

Practice exercise: Assemble a roll of plaster gauze, a bowl of water, and a plastic mask-form. Cut small (1" × 2–4") pieces of the gauze. One by one, dip them into water and place them on the mask, building the mask up until it is at least two layers thick. You can add texture and shape to the eyebrows, mouth, forehead, or any other part of the mask. Children revel in sculpting details like cigars, horns, and big eyebrows. These masks are generally too

fragile to wear, but they can be made ready for hanging by adding holes on the sides, while still damp, with an awl. Set the mask to dry; this will take two or three days. Then it is ready to pop off the form and ornament. You can add paint inside and out, sequins, buttons, ribbons, natural materials collected outdoors, feathers, and nuts and bolts—the sky is the limit. Use hot glue or a clear school glue for attaching these items.

Clay, depending on the type, can be a resistive or fluid medium. Unless you have access to a kiln or an oven, use air-dry modeling clay, which is usually resistive and requires some strength to use. You can purchase quite inexpensively a packet of wooden tools for working clay and also collect tools for carving and pressing designs into the clay; these include combs, forks, hardware, and wires. To cut portions of a large block of clay, use wire, each end of which you should secure to a pencil by wrapping the wire ends around the pencils. Holding the pencils, slice the clay with the wire. Playdough is a much less resistant clay option. As a more fluid medium, it is not as well suited for construction, but it can provide a soothing and expressive kinesthetic experience. As with finger paint, clay can evoke unpleasant memories for some children who have experienced certain kinds of trauma, so it is especially important to allow children to choose whether or not they use clay.

> *Practice exercise*: Make up the recipes for no-cook playdough in the resources section at the back of this book, and assess whether you have the equipment and space to support children making up batches at school themselves.

Sewing Materials

Midyear in a school is a good time to introduce *hand sewing* to ArtBreak groups. Sewing is one of the few media/processes in an ArtBreak studio that works across the span of the expressive therapies continuum. Designing, taking measurements, and cutting out fabric are processes that require cognitive and creative skills. The rhythm of hand stitching is a kinesthetic experience that children

Sewing spans the expressive therapies continuum. Precision and problem solving are required to create a pattern and prepare fabric while the repetitive nature of hand sewing can be relaxing.
Photo by Josh Birnbaum

are usually surprised to find very relaxing—and sociable when done in a group. Sometimes children undertake projects that can take a while to complete, and it is okay for adults or older children to pitch in and help. If a young child wants to make a really big pillow, and you have fabric to accommodate the project, your stitching help can encourage the child to complete the project. I never hesitate to help out if a child *must* finish a sewing project right away—perhaps because it is a birthday present for someone—and some fast stitching is needed. Wrote one child in his ArtBreak journal at the end of the session: "Today I sewed. The day was great."

We use stitching tips from the *Alabama Stitch Book*: Our needles are double threaded with button-craft thread for a basic one-quarter-inch running stitch. We like to let our seams, stitches, and knots show because we are proud of our work. These tips include:

Double thread your needle with a knot at the end.

"Love" the thread to straighten it and ready it for sewing: run the length through your thumb and forefinger three times.

To tie off a seam use a double knot.

Button-craft thread is strong and will not tangle as easily as thinner threads.

Leave half-inch tails with knots at the end of seams. Over time the tail will wear away, so a longer tail will help a finished project last longer.

Children will enjoy all kinds of fabrics and textures that you are able to offer: cotton prints, cotton flannels, corduroys, fake furs, wool tweeds, and fleece are all popular with children for pillows (human, pet, doll, and tooth fairy), scarves, skirts, quilts, wall hangings, and baby blankets. If you keep a good supply of laces and ribbons on hand as well, they will be used.

> *Practice exercise*: If you are not a sewer, mastering pillow construction can carry you a long way and help you feel comfortable with trying other projects. Children love to make pillows in all sizes. Using an 8½" × 11" sheet of paper as a pattern, cut out a single layer of fabric. Fold the fabric, wrong sides together and right side facing outward, to form a 4¼" × 5½" rectangle. Pin in place. Using a running stitch and matching or contrasting button-craft thread, sew around the three open edges with one-quarter-inch stitches. Your seam should run about a half-inch in from the edge of the fabric. You are proud of your stitches, so let them show. Leave a three- to four-inch gap. Through this gap stuff the pillow with polyester fiberfill, which can be purchased most economically in ten-pound boxes. Then sew up the gap. Voila, now you have a small pillow. If you want to ornament your pillow with buttons, sequins, or anything else, do so *before* you fold and sew.

Embellishing Materials

Embellishments are flourishes and features that enliven and ornament the works created in ArtBreak.

Who doesn't enjoy rummaging through a button box to pick out just the right thing? *Photo by Josh Birnbaum*

Although the possibilities are nearly endless, here is a list of suggested items to have on hand in clear plastic containers.

Sparkles: sequins, rhinestones
Plastic "googly" eyes
Buttons
Feathers
Found objects in nature: such as pine cones, sticks, and seashells
Laces
Strings and ribbons
Glitter glue
Alphabet letters
Small metal objects
Stickers
Tags

Tools for Cutting

It pays to buy a sturdy brand of *scissors* like Fiskars; get pairs in both smaller children's sizes and in a few larger sizes. Have scissors compatible for both left- and right-handers. You can add fancy scissors that cut wavy or zigzag patterns. Pinking shears, large sewing scissors that cut a zigzag, nonraveling edge on fabric, are a nice addition to a sewing basket. I use a yellow Stanley or Olfa brand snap-off blade *mat knife* for cutting cardboard and suggest buying both a small size and a box-cutter size. I keep them in a locked drawer or in my laptop tote bag. When using the knife during a session I keep it on my person in a pocket. I do not allow elementary-age children to use the mat knife: it is my only adult-only tool. A large self-healing cutting mat, available at art-supply, craft and sewing stores, is helpful in protecting worktables from marks while you are cutting cardboard. A *metal straight-edge ruler*, 18" or 24" long, is a helpful and safe edge to use for cutting cardboard. Should your scissors become coated with glue or paint and, therefore, hard to use, clean them up with mineral spirits. I do this at home as mineral spirits are toxic. Most schools and many self-service, office-supply stores have a large, heavy-duty paper trimmer good for cutting large sheets of paper to smaller sizes. I also have an awl for making holes in cardboard for stringing things through and attaching pieces together with brads.

Do not underestimate the utility and beauty of *tearing* rather than cutting paper. Papers that are hand torn rather than cut out with scissors give a soft edge for collages, and watercolor paper torn rather than cut to size has a beautiful edge. To tear watercolor paper use a *bone folder*, available from art-supply stores. Fold the paper to its desired size and make a crease with the edge of the bone folder, folding and creasing back and forth several times so that the creasing weakens the paper until it is ready to tear.

Use scissors to cut or hands to tear duct tape, a multipurpose fastener.
Photo by Josh Birnbaum

Tools for Fastening

You will need a few varieties of *glues* and *tapes*. I keep glue sticks and plastic bottles of clear school glue in a basket. It can be helpful to empty a bottle of glue into a small jar so that the glue can be applied with a paintbrush dedicated to that purpose. In another basket I keep clear plastic tape and rolls of duct tape in basic gray, as well as rolls in a few other colors. I learned to give an introduction to children about duct tape after a fifth grader once applied a piece to her mouth. Luckily her skin was not injured when she removed it, but I decided this was one trial-and-error lesson I did not want children to undertake. Give a hands-on demonstration on how to cut tape (use scissors or fingers, never teeth), and how to use it (for fastening construction materials or making things, never on the body).

For several years I did not offer *hot glue* as I felt it was a shortcut that circumvented developing more complex and original ways of fastening. Besides, the children never asked for it. Then they did, so I brought a hot-glue gun (its use supervised) into the studio. We learned that it works well for smaller cardboard items and some embellishments and not so well for holding large, heavy boxes together or affixing lots of tiny embellishments where the lumps and strings of the glue interfere with the look of the object. And, to the horrified delight of the children, we learned that hot glue melts some plastic materials.

Brass fasteners, or brads, are made for fastening papers and are also very useful for building with cardboard as well as embellishing. Brads, unlike hot glue or duct tape, allow one to build movable parts. They are available at office-supply stores and are quite cheap. I get the half-inch size.

Tools for Measuring

A few measuring tools are helpful and take up little space.

- Steel rulers in various lengths can be used for measuring and trimming cardboard.
- For sewing, a fabric tape measure that can be rolled up is helpful.
- A steel, retractable tape measure is useful and fun. Demonstrate how to retract it safely, away from fingers and people.

Measuring tools can be a springboard to projects. One year an early-elementary-grade student spent many weeks using a retractable tape measure to document lengths and widths of objects in the studio. He measured shelves, doors, cabinets, boxes, and desks and wrote down the dimensions in his ArtBreak journal. Then he asked to watch a video about road construction, which we selected from YouTube on my laptop. At midyear, using his new skills, he began designing, building, and painting cardboard objects.

Tools for Sewing

If you decide to introduce sewing to an ArtBreak group, collect a small box of supplies. Here are some basics:

- Scissors dedicated to cutting fabric
- Packet of needles: larger size sharps or quilters
- Pincushion and pins
- Tailor's chalk triangle for marking a cutting line
- Button-craft thread in at least white and black. Add a few colors as you observe what the children enjoy and ask for. Button-craft thread is strong and does not tangle as easily as thinner threads.

If you enjoy offering sewing you can add pinking shears, thimbles (a useful novelty), thread in many colors, zippers, and other fastenings. I haunt thrift stores for these things. As children decide to make things like stuffed animals, or aprons and other clothing, you can work with them to fashion patterns from newsprint. I save these patterns, sometimes pinning them on a bulletin board, as inspiration for and use by other children.

Tools for Sharpening

Elementary-art educator Tami Benyei shared with me her favorite brand and type of *pencil sharpener*: the CARL Angel-5. It is a manual sharpener that gives a perfect point in no time, every time. It is better than any electric sharpener I have ever tried, including expensive ones. The Angel-5 comes in a number of bright colors. I also keep a couple of the tiny metal sharpening cubes on the table for the sake of variety.

Tools for Cleaning

We introduce cleaning supplies as tools so as to support the importance of cleaning up as a part of ArtBreak. Mainly, we have on hand

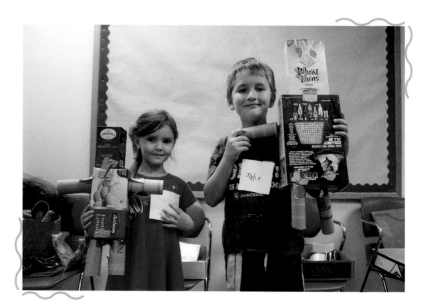

Construction projects using boxes and multiple ways of fastening
require planning and willingness to persist in bringing a vision to form.
Photo by Josh Birnbaum

- Stacks of colorful washcloths or dishcloths
- A large plastic cup or a small tub for used paintbrushes
- A trash can
- A recycle bin for anything that can't be re-used in the collage box

At the end of the day I go over the worktables with an all-purpose, school-safe household cleaner in a spritz bottle. I know teachers who like to use white vinegar mixed with water (one-quarter cup vinegar with one cup water) to clean their classrooms. If you have no sink handy, you can make do quite well with

- A spray bottle of water or diluted vinegar for wiping tables
- Washcloths or dishcloths
- A bucket for used washcloths and paintbrushes

I take home dirty washcloths, run them through the washer, and hang them outside to sun dry on a rack. We also have a bin of smocks for children to don when they paint. You can purchase denim aprons from art-supply stores; I did so one year and they all disappeared at a laundromat in the summer. Now I make smocks from thrift-store shirts.

Instruction for making smocks: Gather T-shirts in different sizes, preferably all-cotton shirts, as they are more absorbent and wash up cleaner than a polyester blend. Cut off the sleeves, leaving the seam and selvage on the smock. Trim off the bands at the bottom of the cut-off sleeves, again including the selvage with the band. Snip each circular sleeve band so you have one long piece. Cut a six-inch slit in the back at the top of the shirt, turn under the edges one-quarter-inch and stitch down. Sew the two sleeve-band pieces at the very top of the slit top for ties. I like to hand-sew these, as it is quick and relaxing. Stitch around the armholes, or not. An alternative smock can be made from all–cotton, button-up shirts. Leave the sleeves on, or trim and sew to the length you want as you please. Cut off the collars as this makes the smocks easier to put on and more comfortable when they are worn backward and buttoned up the back. Illustrated instructions for making smocks are in my ArtBreak blog at http://briarwoodstudios .wordpress.com/.

If you are given boxes and bags of tools and repurposed materials, save them for an ArtBreak group and unpack them with a little bit of fanfare. "Look what we have been given!" In this way even the simplest items become treasures. Cardboard boxes are examined for their construction potential, a box of seashells is exclaimed over, a really generous stash of acrylic paint is immediately put to use painting a shelf. Once we received a huge bag of red plastic cat-food lids all the way from Columbus, Ohio. "From Columbus!" the children exclaimed in wonder and began to use the lids for palettes, toys, and robot eyes.

The Soul of the Studio

We're not told what to do. Your mind is not in a can.

—Sixth grader

SOUL HAS many definitions. The one that best describes the soul of an ArtBreak studio is emotional warmth. In an ArtBreak group the expressive therapies continuum, attention to group process, and a child-centered and choice-based approach animate an atmosphere of structure and freedom that helps students feel safe and able to work according to their own creative impulses. Such an environment is supported by both physical structure and process. This chapter gives suggestions for a physical space that is stocked and supplied to fit your budget, your space, and the needs of the children. There are also tips for creating psychological space that supports freedom.

WORKSPACE

Adapt your program to the space at hand. If you travel with your ArtBreak materials, use portable bins. I like the plastic bins that measure roughly 16" × 24" × 7" as they are less bulky than big bins,

A child decided to make this sign to hang on the studio door as a signal that ArtBreak is in session. *Photo by Josh Birnbaum*

are easily stacked and carried, and hold a lot of stuff. Open them, arrange the contents within, and you are ready to go. You can offer a program with the supply "basics" (listed in chapter 3) in three of these bins plus a bucket with cleanup supplies. Investing in a folding hand truck makes it easy to travel with your supplies. If needed, you can carry construction/3D-design repurposed materials in a plastic trash bag, the kind with a drawstring closure.

A sketchbook-based ArtBreak offers a lot of economy of space and materials. Have the children build their own sketchbooks and work in them each week, building more as they fill them up. Following are directions for a simple 12" × 18" sketchbook made from purchased and repurposed materials (you can make any size that seems right for your studio and students):

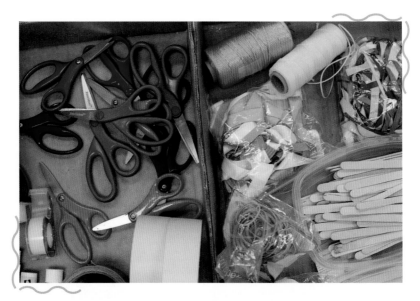

Shallow cardboard boxes stacked in a portable bin can be easily set out on a worktable to form a pop-up studio. Stackable plastic boxes that clip together also work for pop-up storage. *Photo by Josh Birnbaum*

Materials

- Standard-size (12" × 18") white drawing paper
- Construction paper (1" × 18") in various colors
- Finger-paint paper
- Newsprint or newspapers cut to size
- Any extra kinds of paper you can find—wrapping papers, brown kraft paper—cut to size with an XL paper cutter or a long steel ruler and a mat knife on a cutting surface
- Cardboard backs (12" × 18") for a sketchbook; you can precut them from repurposed cardboard
- Front covers made of a heavier paper such as brown kraft paper
- Brass fasteners, one-half inch in size
- An awl

Procedure

Set the papers out in stacks. Explain about the types of paper and how they can be used, especially the finger-paint paper. Have each child choose a cover sheet and twenty to twenty-five sheets. They can stack them on a sheet of cardboard backing. Using the awl, help them punch three or four holes on one short side of the stack. They can then fasten the stack together (cover on top) and onto the cardboard backing with the brass fasteners. After this, suggest that the children ornament, label, and/or paint the cover however they choose. They should add their names somewhere. The sketchbook will work for drawing, painting, collage, and even pop-up sculptures.

A whole room dedicated to a working ArtBreak studio should be in every school. If you are a classroom teacher, you can dedicate a corner of your room to ArtBreak and offer it as a small group activity, or you can bring out bins and have an ArtBreak for the whole class. As a school counselor, I adapted my ArtBreak sessions to the space available to me in schools: a few bins stacked in a corner, sketchbooks, a few shelves and a table in a small room, or a whole studio room with a sink.

With attention to a few details, any space in which you work has the potential to create an atmosphere of support and creativity. *Music* sets a tone. I played the classic jazz CDs for five years in every studio session. The warmth and rhythm of jazz have near-universal appeal and set a casual, busy, and harmonious tone, a window of calm and collegial activity in the day. The children came to associate the music with ArtBreak and usually reminded me if I forgot to put it on. For the same reason I sometimes played contemporary acoustic guitar CDs. Children, and adults who may be helping you, invariably ask for a radio station or a current pop song, but I steadfastly hold to my choices.

Lighting helps create the soul of the studio. If you have natural light from a window, you are fortunate. Open blinds wide, pull back or take down curtains, and remove anything hanging in or affixed to the windows. If your window looks out on a very public space or

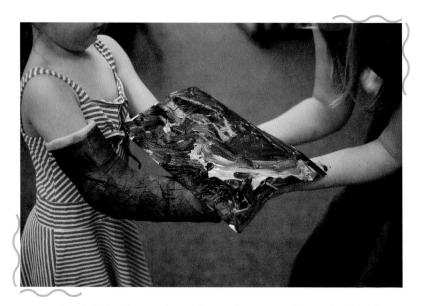

Any child is able to make art if given the support she needs. *Photo by Josh Birnbaum*

perhaps has an unattractive view, such as mechanical systems or a dumpster, hang a sheer curtain on a spring rod in the bottom half of the window. The old fluorescent-tube lighting found in many schools can be uncomfortable to work under, partly because its slow flicker rate can be detected by our eyes. If you are going to turn them off, you will need enough incandescent or new fluorescents in fixtures around the room to light the workspace adequately.

Water in an ArtBreak studio has practical and therapeutic aspects. On the practical side, you'll need water to clean brushes and reusable containers, running water to wash hands, and water to dampen cleaning cloths. If you don't have a sink handy, you can put brushes and containers in a bucket and wash them later in a sink. Have a stack of dampened washcloths ready for wiping tables and for children to give their hands an initial wiping (follow up by having them visit a sink in a restroom). Water can also be relaxing: swishing the hands in a dish-

washing pan full of water, pouring, rhythmically spreading water on a natural sponge on a finger-paint paper, using liquid watercolors from a dropper bottle on wet paper.

Technology is a nice addition to an ArtBreak studio. A laptop is handy for students to pop open and search for images, look for technical instructions, or read up on a topic. Students can use digital cameras, phones, or other devices to take pictures and make movies, upload to the laptop, edit, print, or make e-presentations. If confidentiality is not a concern and family permission is given, you can work with groups of students to create a blog for their work. If you work in a school or other organization, be sure to check your media policies.

You will want to support students who need accommodations so they can comfortably and easily do their best in ArtBreak. School occupational therapists are a wonderful source of consultation and assistance. They can:

- Observe a student and suggest support strategies and modifications to adapt the studio
- Check your ArtBreak studio to eliminate any barriers that may limit student participation
- Bring in assistive technology as needed
- Identify physical and behavioral assistance needs for children

Call on these experts, as well as school counselors, school psychologists, and school nurses, for they are trained to support the needs of all students. I have asked for and received their help in teaching shoe-tying, accommodating a child who worked from a wheelchair, supporting the monitoring and medication needs of children with diabetes, supporting a child with no oral language, altering an environment to best support a child with autism, communicating with hearing-impaired children, offering art making to children with traumatic brain injuries, and supporting children with mental-health needs.

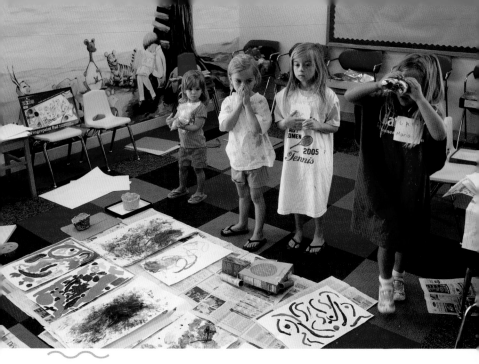

If you are working in a space with no permanent drying rack, newspapers on a carpeted room or hallway floor make a fine drying space.
Photo by Josh Birnbaum

Finally, you will need space for work, display, and storage. A worktable with a formica or smooth wooden top cleans up well. If you have space, two tables—one for wet work and one for dry work—are handy. Some children like to use the floor also. If you have the luxury of storing your materials permanently on shelves, use clear containers where possible and open them up when it's time for ArtBreak. An inviting and accessible display of materials encourages art making. One way to group and display your materials and supplies is by function:

- Drawing
- Painting
- Collage
- Construction
- Sewing
- Embellishments

Two children decided to make this sign for a summer community ArtBreak program. *Photo by Josh Birnbaum*

Send all work home with its makers or else your studio will fill up fast. If need be, store work in progress in a designated spot: top shelves, on top of cabinets, and under a worktable are all good options.

Carpet is the bane of art studios, but I have worked successfully in carpeted rooms by asking children to speak up if they spill paint, so we can clean it right away; putting down a plastic sheet under the drying rack; and putting down old newspapers if I use a carpeted area to dry paintings. If you do your best and still leave stains on the carpet, don't worry about it. You're working with children.

PSYCHOLOGICAL SPACE

Here are ten suggestions for creating a psychological atmosphere of freedom and safety so children can work according to their creative impulses.

1. Facilitate rather than direct. Support students with open-ended questions: "What do you need?" "What can I help you with?" "What does your plan look like?"

2. Keep a list of "Things We Need" posted on the blackboard or on a chart so students can make suggestions and ask for materials: a sewing machine, a potato for making prints, fake fur, more colors of thread, toothpicks, a rolling pin for clay, poster board, pliers, rolls of paper, and glitter glue are just a few items that have appeared on the board in our studio.

3. Avoid kits and preconceived projects; do not stock them in your studio or offer them to students. Support students in developing and making their own choices of projects and materials. If you receive art or project kits as donations, take them apart and mix the bits in with your other supplies.

4. Handle students' work with respect and care. Ask them to sign their pieces as artists do. If possible, have a drying rack for paintings. Offer recycled bags or boxes so students can transport their work home safely.

5. Stick to your two rules (see chapter 5): Take Care of Each Other and Take Care of the Stuff. Remind the groups as needed.

6. Offer a take-a-break spot for the occasional instance when a child is frustrated or angry. I use a chair at my desk or outside my room.

7. Remember that the studio is choice-based; students choose their own work.

8. Do not allow ArtBreak to be used as a reward. If a student is participating in an ArtBreak group, it is part of his or her week and not contingent on behavior. It may be that ArtBreak supports positive behaviors and provides a needed break in the day. Taking this time away can make things worse.

9. Attend to your language. Talk about children's work in specific ways rather than praising with "I like" statements. For example, rather than, "I love the colors in your painting!" try, "I noticed that you tried out a lot of ways to combine and mix colors." Instead of, "You worked really hard on your robot," try, "You kept trying different ways to get your robot to stand up; you kept on problem solving."

10. Attend to and document the process of the group and the individuals in it, including yourself. Notice and document with notes and photographs what students are learning through their work in sessions. For one student, an offer to help another student might be a big step. Problem solving an art "failure" may be important learning to another. Document your own learning and process as well. I keep a notebook for each ArtBreak year and try to remember to take a few minutes after each session to reflect on and jot down learning, questions, joys, and frustration. A template for a facilitator's reflective journal follows.

Facilitator's Reflective Journal

Thoughts, Feelings, Lists, Diagrams, and Reminders

SESSION DATE: _____ SESSION TIME: _____

Process:

 Individual:

 Group:

Materials Needed:

Feelings:

A psychological space of freedom and order creates authentic self-directed learners. Susan Ambrose and her fellow researchers describe motivation as one of the foundations of encouraging self-directed learning: "Students' motivation generates, directs, and sustains what they do to learn." They note that motivation is, in turn, affected by a child's subjective value of a goal: he or she must find it interesting and relevant; a child must also have positive expectations for successful attainment of that goal. In ArtBreak children choose their own work in the presence of a facilitator who stands ready to assist them in bringing it into form.

Procedures

A major clue to mental and psychosocial, as well as psychophysical, health lies
in the spontaneous and innately creative imagination of childhood.

—*Edith Cobb, The Ecology of Imagination in Childhood*

IN THIS chapter you'll find suggestions about referrals to an
ArtBreak group; timing; and considerations like tricky art topics,
ethics, and developing a community of support. If you are a class-
room teacher you'll notice throughout suggestions for implement-
ing the program with a whole classroom. The chapter has two parts:
assembling your group or groups and special considerations.

ASSEMBLING A GROUP

I first envisioned our ArtBreak program as a "drop in" format and
therefore organized a Monday sign-up sheet so that teachers could
refer students to drop in at certain times during the week. I had
planned for eight students per group and hoped to offer a system
that gave teachers the flexibility to refer a student who needed im-
mediate support that day. But after a week of this system, teachers
asked if their students could continue coming every week, and the

children most certainly expected to be able to continue. So our first lesson concerned the need to change to a formal-referral- and family-permission-based set of groups that would continue intact throughout the school year. Classroom teachers have the flexibility to offer a whole-classroom- or centers-based program, so that everyone is able to participate.

If you are working in a school, begin ArtBreak groups in early October, thereby allowing six weeks for teachers, students, and families to settle into the school year. If you are introducing ArtBreak groups to your practice in a whole school, clinic, or other organization, you will want to let the entire organizational community know about the opportunity for referrals. Announce it at a staff meeting; hold a staff preview featuring your materials and your space, whether it is a whole room or a pop-up studio in a bin. If you have a fall open house at school, invite families to drop in, and put an article in your school newsletter announcing the program. Classroom teachers can send home an informational letter. Have your referral forms ready for all these events, and make them available to families, teachers, and community therapists who work with children in your school. A referral form, based on the expressive therapies continuum and refined over five years, is at the end of this chapter. You will want to use it or one like it to track reasons for participation and referral and to consider questions of student progress.

School mental-health staff (school counselors, psychologists, and social workers) and any other staff assembling an ArtBreak group in a school will want to obtain family permission for each child. Send home a family permission letter with each child referred to your program, even children who are referred by their parents. Classroom teachers may not need permissions and can send home or post on your website a note about beginning the program.

Scheduling

Schedule your group(s) when you have a stack of referrals and permissions. Here are nine tips to help you get ready.

1. Decide how many groups you are able to offer.

2. Think of scheduling no more than eight students per group, unless you have the space to accommodate more and an adult helper each week.

3. Choose the day(s) and time(s) that seem likely to work best with your schedule and the schedule of the school.

4. Forty minutes is a good length of time, within a school, for an ArtBreak group session. An hour is better, but it can be hard to come by during the school day. I tried thirty minutes and found that this was such a short time as to be frustrating to the children and the facilitator. For your own peace of mind, do not schedule groups back to back. Leave time to prepare your space and assemble the children.

5. Work with each child's teacher to schedule an ArtBreak according to what time period would be best for the child to miss from the classroom once a week. I like to make sure no one misses art, music, physical education, and outdoor play. Lunch is not a good time, either, as the children need to eat.

6. Give each child's teacher a card or note with his or her ArtBreak schedule. I gather the participants for the group myself each session, leaving to do so a couple of minutes before the start time to collect the children from their classrooms. Usually, after a few weeks they are waiting and ready. You can make it a point to signal quietly to them to leave the classroom, coach them to leave the classroom quietly, and greet them cheerfully.

7. Mix ages and genders. Combining ages and grades can mediate and change alliances and behaviors that have developed around same age/grade groups, offering new patterns for social relationships and learning. Older children enjoy being with the younger ones, sometimes reminiscing about their own kindergarten or first-grade experiences; the little ones enjoy the occasional help and attention from older children; and both younger and older benefit from working together on projects. Notes Peter Gray, in *Free to Learn*: "The free mingling of children who differ broadly in age is a key element to children's abilities to educate themselves successfully, on their own initiatives. Children learn by observ-

ing and interacting with others who are older and younger than they are."

8. You may need to talk with families and children to make sure they are ready to participate in an ArtBreak group. Because of the relaxed atmosphere that develops, a child who is distressed about a traumatic event, or in the midst of processing trauma with a therapist, may share inappropriate information with the group; in this instance, you can work with the child individually about appropriate sharing. Sometimes you may have a child who has led a life extremely deprived of structure and resources, including schooling; you may need to schedule individual sessions to teach about procedures in the art studio before beginning.

9. Coordinate with the school year. After snow days or holidays pick up where you left off instead of trying to offer additional "makeup" groups. Hold no ArtBreak groups during weeks of schoolwide testing. Instead, offer your ArtBreak space or setup as a haven for children, or teachers, who need to relax. Adjust to field trips; usually, with mixed-age groups, you will have enough children present to hold your sessions. I hold closing sessions at least two weeks before the end of school, as special events fill the school days during that time.

Limits and Rules

Child-art therapist Judith Rubin writes that limits, structure, and a safe and supportive framework facilitate growth and the free play of creative forces.

For this reason we provide structure but not direction, and we do not offer step-by-step "make-and-take" projects; nor do we use kits. Again, resist any urge you might have to bring in to your group attractive ideas from Pinterest. Rubin notes:

> Because a child is small and dependent, he needs an adult to provide him with the physical and psychological setting in which he can freely struggle to order and control . . . so it follows that the adult offering art must provide a framework or structure within which the child can be free to move and to think . . . not a structure

Letting practices like wearing a smock while painting be practical procedures allows the simplicity of just two rules: Take Care of Each Other and Take Care of the Stuff. *Photo by Josh Birnbaum*

Studio guests, with a little prep about the spirit of the studio, provide invaluable individual support. *Photo by Josh Birnbaum*

which imposes, controls, and makes a child dependent, for such a framework is a straitjacket and not conducive to growth. Such a restrictive framework may take many forms, from the use of pre-pared outline drawings, kits, and step-by-step guides, to general-izations about the best size of paper or brush.

Keep rules simple. I began with a long list of dos and don'ts, whittled it down to about half a dozen, and after six months wrote just two rules on the blackboard: Take Care of Each Other and Take Care of the Stuff. I found that things I thought were rules, like Wear a Smock When Painting and Cleaning Up, are actually stan-dard procedures and good practices.

The two rules cover a lot of territory. Announce them in the first session and invoke them as the program moves along to support and reinforce instances of caring behavior or to remind the group when needed.

CONSIDERATIONS

Tricky Topics: Fart Flipbooks and Accidental Firearms

Some art topics are tricky, and anything to do with school violence is one of them. I let students know that we don't make anything that can get them in trouble, alarm others, or cause harm to the artist. This includes facsimiles of guns, as well as the popping of paper bags or bubble wrap. How best to respond to violent content like battle scenes in art made by boys? Art educator Clyde Gaw offers advice on the topic in his chapter entitled "The Secret Art of Boys" in *The Learner-Directed Classroom: Developing Creative Thinking Skills Through Art*, edited by Diane B. Jaquith and Nan E. Hathaway. Gaw suggests that "Boys are socially conditioned and biologically hardwired to weave action, drama, and danger into their imaginary realms." If we shut down their images of imaginary fighting we miss an opportunity to deepen our understanding of children's thoughts and ideas. Rather, as facilitators we might learn to discern what is truly an alarm or warning by encouraging students to share their narratives with us when they create art with fantasy violence. If a student announces, "I made a gun on accident," I ask them to leave it with me. Flimsy cardboard swords are okay, but a fake firearm could set off a chain of reactions that would certainly earn a student a reprimand and, at worst, prompt a violent response. So, no guns. Drawings are another matter. Take the time to ask about the imagery of a picture containing scenes of violence and listen to the narrative that goes with it. If you are concerned about what you see or hear, bring in a school counselor that day to consult with you, and share your concern with a parent or guardian.

A very engaging and earnest fourth grader once crafted a clever object that he called a fart flipbook. You can imagine the imagery! I noted his craftsmanship and originality, and he explained to me the art form known as He-gassen (fart battle), printmaking and paintings thought to be political commentary dating from

seventeenth-century Japan. While you may not want to encourage what you might call bathroom humor, when it emerges I try to take it in stride.

Legal and Ethical Considerations

The setting in which you are facilitating an ArtBreak group, your professional role and affiliation, and your worksite all affect the kinds of permissions you may need to obtain and the information you will want to give to families and others who are providing care to a child in your group. Most school districts have a family-permission form regarding photographs taken of their children at school. Here are four circumstances in which to go beyond the standard school permission for photographs and other student materials.

1. If you are a classroom teacher, send home an announcement about your ArtBreak classroom program and let families know you'll be documenting work with photographs according to your school's procedures and policies.

2, If you think you will be using photographs of students and their work outside the school community, consult with your school district for the right language to include in your family-permission form. Include a permission request for any photographs that you may use in education, teaching, and when otherwise sharing your program with others. A sample form is in the resources section.

3. If you think you may be conducting any research during your ArtBreak program that involves the use of ArtBreak materials, including documentation, surveys, and student journals, check your school or other organization's research-review process and follow it.

4. If you are a school counselor, you have an ethical obligation to consult and coordinate with community mental-health-care providers who see children in your ArtBreak group, so you will want to set up and follow a process for doing that. You may also want to consult with classroom teachers and parents about the progress of their ArtBreak students.

Other considerations with ethical, and possibly, legal aspects concern the public display of student work, privacy of student records, and guidelines for accommodating ArtBreak studio guests. If you provide mental-health care in a school, these are especially relevant questions because of the confidentiality that is a critical part of your services. You will want to consider your school-district policies and your professional standards of practice before making a decision about posting student work in public places in the school or elsewhere. Any written records, such as referral forms and notes, should be kept in a secure place. If you plan to host guests who are interested in observing or volunteering in your ArtBreak group, inform both the school administrator and the children's families, and follow your organizational and professional affiliation policies for guests and other volunteers. I have done so when hosting adult volunteers, who can be a wonderful support to you and your ArtBreak group. You will want to prepare volunteers by sharing with them the framework and approach for ArtBreak and modeling supportive (rather than directive) work with your group.

Developing a Community of Support

Here are seven suggestions to begin developing a community of support for your ArtBreak program.

1. Send home "progress reports" to families, with a copy to classroom teachers. A sample progress report is in the resources section.

2. Invite families, school staff, and friends to donate materials for your ArtBreak group; send a list of the kinds of thing you use.

3. Partner with the art educator in your school as you develop and offer your program. Children in schools with art educators will come to your program with many skills and a mindset for studio art. Your art educator can help you identify good sources for supplies, share materials and tools when available, and collaborate.

4. Send home to families ideas for what to do with all the projects that come home: display for a while, take apart and

A check-in poster is a form of data collection. Encourage the choice-based nature of the studio by asking children to make marks of their choosing by their names. *Photo by Josh Birnbaum*

recycle or reuse, scan and post or print for family greeting cards. Also, send home ideas for setting up a home ArtBreak corner, with suggestions for materials. In the resources section at the end of this book is a sample note to send home after your group has embarked on construction projects.

5. Present an ArtBreak workshop for continuing education units for teachers in your school district, using information from this book.

6. Ask businesses to partner with your program by donating cardboard boxes and other recyclables, as well as other supplies you might need. Office-supply stores have lots of interesting tiny to middle-size boxes that are great for construction. In grocery stores the candy and organic frozen-food sections are treasure troves of nice-sized boxes that become available when products are being unpacked and stocked. Home and building-materials stores like Lowe's and Home Depot have extra-large appliance boxes.

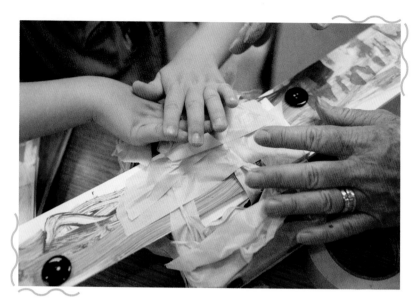

The small hands here painted foam board and stuck all the parts together to make an airplane. *Photo by Josh Birnbaum*

7. Be available to the school community for art emergencies, such as duct tape for shoe repair, a last-minute Valentine box, a quick birthday or sympathy card, a prop for a talent show, a photo of children's work for a school newsletter, a tool, a bit of yarn, a box of watercolors, and a sign for a special event.

Documenting Student Work

In addition to writing a journal, taking the time to photograph student work and keep structured notes for each student will help you reflect on your ArtBreak practice. Such documentation can help you identify what new materials are needed, think about possible adjustments in anything from your workspace to the type and amount of encouragement that you provide to individual children, prepare progress summaries for the children's families and/or teachers, con-

sult with teachers on skills to reinforce in ArtBreak for individual children, understand larger processes like creativity, and refine the role of the expressive therapies continuum in your practice. You can easily generate a lot of photographs and I've found that uploading them to secure files helps me keep track of them. The resources section has a template that you can alter to fit your needs for keeping structured notes. Half-sheets are sufficient and save paper. You can prepare student progress reports midway through your group to send home to families and give to children's classroom teachers. I have prepared them to have on hand for winter parent-teacher conferences. Samples are included in the resources section, altered so they are not identifiable. I like to illustrate these reports by digitally cutting and pasting photographs of the students' work and excerpts from their journals into the documents. While creating these portfolio-style reports is time-consuming, they do give a full picture of a child's work and can highlight strengths that may not be obvious to others.

PART III

FROM START TO FINISH

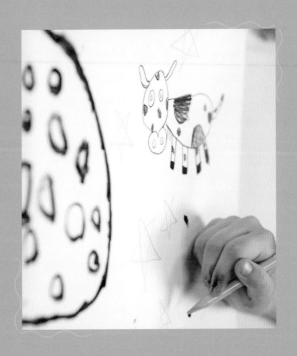

Session Plans

I want to do it every day because it is fun.

—*Eight-year-old ArtBreaker*

TEACH CHILDREN how to take care of the materials and use the tools in the studio and then give them the freedom to create and bring into form whatever they choose. If you read chapter 3 and do the learning exercises there, you will be familiar with your materials and can support the children as they use them. Use the session plans here as a guide to structuring and supporting your groups throughout the year. Each plan is structured in this order: introduction, a list of materials, preparation, demonstration instructions, and (in some cases) notes.

1. First Session: Introduction to ArtBreak
2. Second Session: Introducing Choice and Cleanup
3. Introducing Finger Painting
4. Introducing Collage
5. Introducing Construction: Brass Fasteners
6. Introducing Construction: Robots
7. Introducing Sewing: A Pillow

8. Winter Relaxation: Watercolor on Wet Paper
9. Reflecting
10. Last Session

FIRST SESSION: INTRODUCTION TO ARTBREAK

The first is the only session in which the children are directed. In this session you acquaint them with the rules and get to know the children through the choices they make.

Materials

Multimedia paper and basic drawing/painting materials include: boxes of watercolors, bowls for water, watercolor brushes, school paint and brushes, graphite pencils, color pencils, water-based markers, crayons, and chalk pastels. Provide three interesting objects for children to draw or paint: plants, animals, and other objects from the natural world are good choices, as are compelling objects from other sources. I alternate among a green PlayMobil® dragon, a ceramic frog, large seashells, a live flowering plant, an iron, large nuts and bolts, and a boot. You'll also need your smocks and cleanup supplies.

Prep

Gather materials, post the rules by writing them on the board or hand painting them on cardboard, and have your music ready (see chapter 5). I use two rules: Take Care of Each Other and Take Care of the Stuff.

Demonstration

Have the children introduce themselves to each other as you gather them from their classrooms. Assemble them around a worktable

and welcome them to the space. Let them know they will be attending together each week at this time, except for days with special events and holidays. Also let them know they have been referred to the group by a teacher, a parent, or other grown-up caring for them, so that they can work on various skills while making art. Here is a time for you to speak of how making art together in a group can help a person with various things—such as relaxation, social skills, and problem solving. Announce that today you will give them directions on what to make, and that after today they will make their own choices. Read to them the two rules that you have posted. Allow the rules to fill the room, then let them know it is time to get to work.

Point out the drawing and painting materials you will be using today, including the paper. Let them know that today you would like them to choose paint or a drawing material and create a picture—a drawing or a painting—of an object. Let the children know to put on a smock if they choose to paint, and invite them to share drawing materials as needed. For example, if two children decide to use color pencils, they can share the pencil containers.

Ask if anyone has a question and then ask them to begin. Watch for ways that you can help them arrange themselves and their materials comfortably, notice what medium each chooses (fluid or resistive?), and remind about and help with smocks. Your role is to support rather than direct. As they begin to finish up, remind the children to write their names on their work—"An artist signs his or her work"—and invite them to create a title as well. Titles are not essential but names are so that if the paintings are left to dry you can get them back to the makers. When it is time to clean up, direct the children to the place where you would like them to put their used paintbrushes, show them where to clean their hands, and offer them damp cloths to wipe up the work surface. (I use washrags; see chapter 3.) I like to document their work and use my phone camera to take pictures of each child's finished piece, as well as any work in progress. (You will have already obtained family permissions to take and use photographs for research and teaching purposes; see chapter 5.) I try to take photos of children over their shoulders, showing

their hands working, to preserve privacy. Have the painters put their work in a place to dry; I have used both hallways and drying racks. If you are using a floor and there is a lot of paint, put newspaper down first. Invite the children who chose to draw to take their work home with them. Toward the end of the day, when the paint has dried, you can take paintings to the children's classrooms.

Close the session by reminding the children they will be returning the next week, and offer them an encouraging word for the day or week.

SECOND SESSION: INTRODUCING CHOICE AND CLEANUP

In this session you will support students in their own art-making choices and teach them about cleanup, an important part of art making for which the last five minutes of each ArtBreak session should be allotted. As Judith Rubin says, "Clearly defined limits of time facilitate creative work."

Materials

At this stage you will be offering a very basic set of materials and tools. Referring to the list of basics in the resource section at the end of the book, have ready at least some of those basic materials for drawing, painting, and embellishing, as well as the basic tools listed.

Prep

Have available your handmade cleanup sign. Here is the text that I use:

Steps to Cleaning Up
Put away
Recycle or throw away
Wash
Wipe

Some children need a little help getting used to the choice-based environment. You might make available, either as a sign or a note, a drawing prompt: "What does an artist draw?" I use this one:

What does an artist draw????

 Something you remember . . .

 Something you imagine . . .

 Something you can see . . .

 A scribble . . . or other marks

Demonstration

Gather the children at a worktable and announce that ArtBreak has three parts:

1. Deciding what to make
2. Working and making
3. Cleaning up (You can ask them to guess what this third part might be.)

Let them know that you are about to teach them about working together to clean up, an important part of ArtBreak. Point out your Cleanup sign, read it aloud or ask a child to read it, and show them the places and objects in the space that have to do with cleanup. Let them know you will give them a signal when it is time to clean up—when about five minutes are left in the session. Decide on a signal (a chime, a dimming of the lights, an announcement) and let them know that you expect them to stop working then and turn to cleaning up. Tell them that it is hard sometimes to stop, but that some work they decide to begin may take two or even more sessions to complete, and that you will save it carefully for them until they are finished. Show them the materials available and invite them to begin. Five minutes before the end, give your cleanup signal and help the group move along to cleaning up. This seems like a lot of detailed instruction about a simple task, but having children stop working to clean up is one of my big challenges.

Note: You may periodically need to remind the group about the cleanup part of ArtBreak and revisit the cleanup signal. After holidays and snow days are a good time to refresh everyone's memories about this part of the session.

INTRODUCING FINGER PAINTING

Finger painting is a great way for older children to revisit, relax, and enjoy what Viktor Lowenfeld calls the scribble stage of art making (common to ages two to four) in his book, *Creative and Mental Growth.* The joyfulness of the mess is part of the point of finger painting. Just keep calm and follow these tips.

Materials

Provide finger paint, finger-paint paper, washcloths, a bucket, newspapers (optional), smocks. If you do not want to bother wiping up paint, have the children put a layer of newspapers on the table. It can be simply rolled up and thrown away.

Demonstration

Each finger painter should don a smock. A few damp washcloths on the table will allow children to wipe their hands if they wish. They are also good for removing most of the paint before using the sink for a final washup. Demonstrate how to use the paint: how to open and close the cap; how to squirt small amounts on their paper at a time. I keep all the finger-paint bottles in a tub and teach the children to get what they need. We use red, blue, yellow, black, and white; I suggest that children try mixing the colors, inviting them to begin with two. They never fail to be delighted when they make green, orange, purple, and pink. Color magic! See chapter 3 for Miss Shaw's finger-painting instructions.

Have a bucket by the sink for children to deposit paint-covered washcloths and smocks. I carry the bucket home, put the contents

through the washer, and hang the items on a rack inside or outside to dry.

Have the children wipe up any paint on the table.

Finished paintings can dry on a rack, if you have one, or on newspaper spread on the floor. (In a school, hallways are great for this.)

Re-teach prep and cleanup when it's needed.

INTRODUCING COLLAGE

Collage is a prelude to construction and sculpture and can be introduced after the group is about a fourth of the way through its total number of sessions. Do the practice exercise in chapter 3 so you will be familiar with process and materials.

Materials

Have ready basic collage materials; see chapter 5. You will be giving a two-minute collage demonstration, so you will need a glue stick; a small piece of cardboard for a base; and a stack of catalogs, magazines, or other papers.

Prep

Have a stack of different sizes of cardboard for collage base ready in case the children decide to collage, check your supply of glue sticks, and get out the bin or box of collage materials that you have collected.

Demonstration

Gather the children at a worktable. I stand behind the worktable and have them stand in front of and beside me. Ask if they have heard of collage: older children may have been introduced to it by their school's art educator. Make a quick collage, talking about what

you are doing: selecting pictures that you like, making a birthday collage for someone, creating a sign with different kinds of letters, or something else. Tearing images and letters creates a soft edge and tearing can be satisfying. Arrange and glue until you have filled the cardboard base. Don't worry about being exact; you are creating quick gestures of shapes, colors, and images. With your glue stick add a few embellishments—sequins, a feather, a bit of foil, a plastic bottle cap.

Note: The children may or may not decide to make collages after your demonstration. In early February, I make a couple of small and simple Valentine collages and set them out as ideas; you can also set out frames that you have collected from thrift stores. Children may want to paint or ornament them before putting in their collages.

INTRODUCING CONSTRUCTION: BRASS FASTENERS

Begin to introduce sculpture and construction with found objects and recyclables about a third of the way through the total number of sessions offered. Once you introduce construction there is no going back; children will spend many weeks making things in this way and they will use a lot of cardboard boxes. See chapter 3 for suggestions on what to collect and where to find it.

Introduce construction simply by showing children ways they can fasten materials together. This session plan is a brass-fastener lesson. Watching a child struggle to attach a cardboard tube to a cardboard box made me think hard about what I could offer students beyond tape in the way of fastening. I thought of brass fasteners and found them at the grocery store. After using them to attach flat pieces of cardboard, I thought of how we could clip, fold, and use them to attach boxes and tubes. One year a child made a very large robot, its head bristling with many tubes fastened in this way.

Materials

Provide flat pieces of cardboard, an awl, a couple of cardboard tubes (giftwrap tubes cut into shorter pieces), and one-half-inch brass fasteners.

Demonstration

Gather the group at a worktable and announce that today you want to show them a special way to fasten things together. Give each a brass fastener and invite them to examine it. Then bring out your awl; I write "A W L" on the board to show how the word is spelled. Explain that it is a strong, sharp tool used in woodworking and to punch holes in leather. For this reason it is a grown-up tool that we use in the studio to make holes. All they have to do is ask and you will use the awl to punch a hole for them. Now demonstrate by punching holes in two pieces of cardboard. Invite a child to put a fastener into the hole, then pull its arms apart and push them firmly down. You have created a movable part. If needed, you can stabilize the piece by adding a second set of holes and another fastener.

You can also demonstrate how to clip the edge of a cardboard tube to make tabs. (This requires five or six one-half-inch cuts evenly spaced.) Fold the tabs out; line up the tube on a box, or other cardboard surface; punch holes through both planes of cardboard; and attach the fasteners.

Note: A hot-glue gun is a handy tool because its glue dries very fast, much faster than liquid school glue. It is especially useful for fastening small embellishments and gluing small cardboard items that are not heavy. Hot glue will not hold very long objects in place for very long. Nor will it hold large boxes together. I wait to introduce the hot-glue gun until construction and sculpture making is well under way.

INTRODUCING CONSTRUCTION: ROBOTS

Robots are fun and children like making them. A rich collection of materials is inspiring. Collecting some boxes or containers of the same height is helpful for when children start searching for robot legs. Directions to practice robot making are in chapter 3.

Materials

Provide cardboard boxes of all sizes, plastic containers, embellishments, duct tape, masking tape, brass fasteners, tempera or washable school paint, and brushes.

Prep

Gather what you will need to make a small robot: small boxes for the head and body, cardboard or boxes for legs and arms, brass fasteners, and a glue stick or school glue.

Demonstration

Gather the group and announce that you are going to show them how to make a robot. Fasten the head to the body using brass fasteners. Attach the legs and arms with brass fasteners, noting that opening the bottom of the body allows you to reach inside to fold down the brass fasteners. Add embellishments (button eyes, a feather for the head, a fabric scrap for a scarf or skirt), talking your way through your choices so the group can hear and understand your decision-making process.

Note: "How to Make the Robot Stand" is a challenge in geometry and physics. Sturdy, wide legs are better than thin ones, if the robot is large. Children often go for long and thin legs—after all human legs are thin compared to the torso. I found that a suggestion for sturdier legs usually goes unheeded: seeing is believing. You

can always add an observation while you are demonstrating: "Wide and sturdy legs help the robot stand."

INTRODUCING SEWING: A PILLOW

Children love to sew. Once you introduce it, everyone may want to try. For this reason, start simply and be prepared to help at first. First, hand stitch the pillow described in chapter 3 yourself. This is a very structured demonstration, but an investment in how to sew will allow the children to work independently in subsequent sessions. The lesson teaches how to make a pattern, cut and stitch fabric, thread a needle, and tie off knots.

Materials

Supply assorted fabric and fabric remnants, sheets of newsprint or newspaper for patterns, button-craft thread, needles, scissors, pins, pin cushion, tailor's chalk, and fiberfill stuffing.

Demonstration

Assemble the children around a worktable and announce that you are going to demonstrate hand sewing. Ask if anyone has a family member who sews and lead a discussion about his or her sewing. Show the group your finished pillow and pass it around.

Demonstrate how you made the pillow, following the steps in chapter 3 up through pinning the pillow in place. Show them how to thread the needle, "love" the thread, and tie the knot at the end. Demonstrate the running stitch slowly, down and up, for a few stitches. Invite each child to sew a few stitches, passing the pillow around, until only a three-inch gap is left. Invite each child to insert a bit of stuffing, then sew up the gap and invite a child to tie the knot. After this, children in the group can decide if they wish to make a pillow. Stand by to help everyone at once as best you can!

You may have a sewer among your group, and, if so, ask if she or he would help others.

Note: After the pillow demonstration, children can decide on their own about sewing projects.

WINTER RELAXATION: WATERCOLOR ON WET PAPER

Midwinter skies can be gray and cold weather can bring indoor recess; along with this comes a feeling of being pent-up. At the same time, a certain wave of anxiety begins to appear amongst teachers about learning progress and impending standardized achievement tests, and children pick up on this. A nice antidote is the relaxing diffusion of delicate hues of watercolor on wet paper. This is also a relaxing exercise to offer teachers during some window of open time—staff meeting, lunch break, etc.

Materials

Have available watercolor or multimedia paper, dropper bottles of watercolors or watercolor paint boxes and brushes, a natural sponge, and bowls of water.

Demonstration

Tell the group you are going to show them a different way to use watercolors. First wet the paper with the natural sponge, explaining that it was once a real sponge growing in the sea. Then show them how to take a dropper or brush full of paint, drop or spread paint gently on the page, and watch how the paint spreads across the damp paper. Have a moment of awe and exclaim about how the paint blooms! Add a second color and observe how the two blend and spread together. Invite the group to try and be ready with space to dry many sheets of paper.

REFLECTING

Reflection is remembering with awareness and analysis. Helping children reflect on their own work and that of others extends their art-making experience and encourages a cycle of deeper thought. This session is a guide to two kinds of reflection: group reflection at the end of a session, and individual written (or dictated) reflection in a personal journal.

Group Reflection

Two or three minutes at the end of a session provides enough time to begin a practice of group reflection. Ask if anyone would like to share his or her work with the group. If someone steps forward, ask the group to gather around the person's work to see. Ask the artist if she or he has something to say about the work, or a question to ask. You can also ask if she or he would like questions or comments from the group. If so, invite them. If no one speaks up, you can model appropriate comments by noticing aspects of the work in a nonevaluative way. Here are a few examples.

> I notice that you enjoyed using a lot of red paint.
>
> I notice that you must have done some problem solving to get that to work as you did.
>
> Your painting gives me a happy (or sad, excited, etc.) feeling.

Thank everyone for sharing. In this way you will model for the children group-reflection time, and they will run with it. In university art and design classes these sessions are called critiques. The Open Door Art Studio in Columbus, Ohio, calls them "Awesome Time."

Individual Journal Reflection

ArtBreak journals are described in detail within chapter 2. Briefly, you can staple together half sheets of copy paper (assorted papers

ready for recycling will work) with covers of half sheets of card stocks, provide slips of paper with standard questions for children to answer each week, and remind them to take a minute or two in their journals after cleaning up. Questions that encourage extending broad thinking and having insight into oneself are:

1. What did you make?
2. What materials did you use?
3. How do you feel? What are you feeling?
4. What are you thinking now?

I keep the journals in the ArtBreak studio rubber-banded together, according to group. I also keep my own reflective journal after each group, taking a few minutes to jot down what I noticed about the art that was made; problems that need to be solved; new materials and processes needed; child relationships; and child behaviors and interactions. I also note how I felt, what I am thinking, and what I would like to make when I have time. Posting a running list of child-generated feeling words helps children reflect. Here is a short list:

Awesome
Calm
Excited
Glad
Happy
Hungry
Lonely
Peaceful
Sad
Terrific
Tired
Worried
Wow!

LAST SESSION

By now a group or groups have been with you for a number of months and will need a little help as you approach the end of school and the end of the group. This is known as the mourning, or termination, stage of groups. Expect any reaction: expressions of sadness or protest, aimlessness, near-frantic production of art, requests for more sessions or summer sessions.

Plan

Begin talking about the last session about a month before the last group. I like to end a couple of weeks before the last day of school, while schedules are still regular and field trips have not yet begun. This way you can talk with the group about planning for the last day. Here are some ideas for the last session; you and your group will have more.

- Have a regular session.
- Make a slide show from photos you have taken through the year and enjoy it with the group.
- Create a book (electronic or paper) of notes about what they have learned, work samples, or anything else the group would like to add. The book can go in the school library or in your collection.
- Put up an art show for the school and families to see. (This requires saving work and putting it aside.)
- Have festive snacks.
- Make a group work of art and display it in the school.

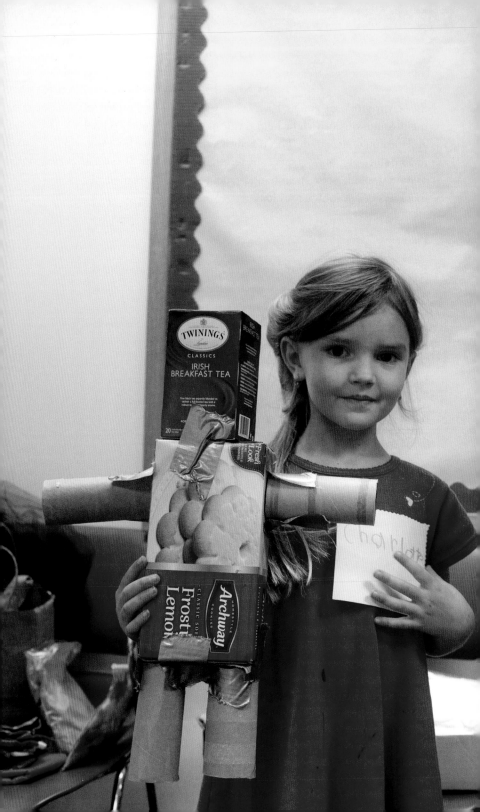

RESOURCES

1. Materials and Tools: Basics and Beyond

2. Developing Your Skills

3. No-Cook Playdough Recipe

4. Request for Donations

5. ArtBreak Referral Form

6. Family Permission Letter

7. Note to Families: What To Do with Constructions

8. Individual Student Documentation Forms

9. Sample ArtBreak Progress Reports

MATERIALS AND TOOLS
Basics and Beyond

BASICS

Drawing

_____ Water-soluble markers

_____ #2B pencils w/ erasers

_____ Color pencils

_____ Crayola crayons

_____ Chalk pastels

_____ Variety of papers, including construction paper and finger-paint paper

Painting

_____ Washable school paint in various colors: red, yellow, blue, black, white

_____ Finger paint

_____ Watercolor sets

_____ Tempera brushes: round and flat in a range of sizes

_____ Watercolor brushes: Flat and round, one-inch size and some alternative sizes

_____ Student-grade, mixed-media (wet and dry) paper

Collage

_____ Collage materials: magazines, papers of all kinds, cardboard for backing

_____ Clear school glue

_____ Glue sticks

Construction

_____ Found and recycled cardboard sheets, tubes and boxes of all sizes

_____ Plastic containers

_____ Beads

_____ Buttons

_____ Yarns and strings

_____ Ribbons, laces, fabric

_____ Sparkles: sequins and rhinestones

_____ Fine-weight twine for stringing beads

Tools, etc.

_____ Sturdy scissors in children's and adult's sizes

_____ Mat or craft knife: box cutter and smaller size (keep secure)

_____ Awl (keep secure)

_____ Metal straight-edge ruler, 18" or 24" long

_____ Glue sticks

_____ Clear school glue

_____ Duct tape

_____ Transparent tape

_____ Pencil sharpener

_____ A dozen dishcloths for cleanup

_____ Small plastic tub or large plastic cup for washing used paintbrushes

_____ Trash can with plastic bag

_____ A bucket for washing things (if no sink is available)

_____ Spray bottle of water or environmentally friendly household cleaner

_____ Smocks, purchased or made from old shirts

ADD-ONS

Drawing

_____ Oil pastels

_____ Artist pencils in H and B lead grades

_____ Erasers: White, pink, or gum

_____ Lead holder for fat graphite stick

_____ Carpenter's pencils and sharpeners

_____ Chalk-pastel spray fixative, milk-based

Painting

_____ Liquid watercolors in dropper bottles

_____ Foam brushes in various sizes

_____ Natural sponges for dampening paper

_____ Watercolor paper in at least 80 lb. weight

_____ Acrylic paint (liquid)

Printmaking

_____ Styrofoam grocery trays (to cut block-printing patterns and glue to a spool)

_____ Brayers

Construction

_____ Fabrics and laces

_____ Clear matte acrylic medium or Mod Podge

_____ Wires

_____ Buckles and zippers

_____ Feathers

_____ Craft sticks

_____ Corks

_____ Spools

_____ Small, safe metal objects and parts of machines

_____ Old jewelry

_____ Plaster gauze for masks

_____ Plastic mask forms

_____ Playdough

_____ Air-dry modeling clay

_____ Wood (small pieces)

_____ Sandpaper

_____ Found objects from nature

_____ Glitter glue

_____ Alphabet letters

_____ Stickers and tags

_____ Jewelry-making findings and fine wires

_____ Fancy scissors (zigzag, wavy)

_____ Bone folder

_____ Hot-glue gun

_____ Retractable steel tape measure

_____ Colorful duct tape

Sewing

_____ Fabrics: cottons, flannels, corduroys, fake furs, tweed and other wools, fleece

_____ Scissors for cutting fabric

_____ Pinking shears

_____ Needles: larger size sharps or quilters

_____ Pin cushions and pins

_____ Tailor's chalk triangle

_____ Button-craft thread: white, black, and other colors

Electronic

_____ Laptop

_____ Editing software for photography and movies

_____ Cameras

DEVELOPING YOUR SKILLS

Sewing tips: Natalie Chanin and Stacie Stukin, *Alabama Stitch Book: Projects and Stories Celebrating Hand-Sewing, Quilting, and Embroidery for Contemporary Sustainable Style* (New York: Stewart, Tabori, and Chang, 2008).

Cardboard tutorial giving technical tips rather than projects for children to copy: http://www.ikatbag.com/2011/03/how-to-work-with-cardboard.html.

Making objects from cardboard: Bevill Packer, *Appropriate Paper-Based Technology (APT): A Manual* (London: Intermediate Technology Publications [now Practical Action], 1995).

Organizing choice-based art education centers: Diane B. Jaquith and Katherine M. Douglas, *Engaging Learners Through Artmaking: Choice-Based Art Education in the Classroom* (New York: Teachers College Press, 2009).

Teaching yourself how to draw: Betty Edwards, *Drawing on the Right Side of the Brain: The Definitive, 4th Edition* (New York: TarcherPerigee, 2012).

Making artist trading cards: Bernie Berlin, *Artist Trading Card Workshop: Create, Collect, Swap* (Cincinnati: North Light Books, 2007).

Making mandalas for personal expression: Susanne F. Fincher, *Creating Mandalas: For Insight, Healing, and Self-Expression* (Boulder: Shambhala Publications, 2010).

Mixing watercolors: Moira Clinch, *The Watercolor Painter's Pocket Palette* (Cincinnati: North Light Books, 1991).

Monotype printmaking: Julia Ayres, *Monotype: Mediums and Methods for Painterly Printmaking* (New York: Watson-Guptill, 2001).

Author's ArtBreak blog with instructions and resources: www.briarwoodstudios.wordbreak.com

NO-COOK PLAYDOUGH
RECIPE

Mix in a bowl:

 2¼ cups plain flour
 2 tablespoons vegetable oil
 ½ cup salt
 2 tablespoons cream of tartar

Add:

 1½ cups boiling water
 Food coloring (optional)
 Few drops glycerin for shine (optional)
 A drop or two of essential oil such as lavender or mint
 (optional)

Stir. Allow to cool, remove from bowl, and knead for several minutes until the dough is no longer sticky.

 Store in Ziploc® bags or plastic containers with lids.

REQUEST FOR DONATIONS

Hello Friends,

If you are doing any cleaning or recycling we can re-purpose your "stuff" for our ArtBreak studio. Here are some ideas of things we could use:

Buckles, zippers

Buttons and beads

Cardboard boxes, 18" or smaller. We also love an occasional BIG BOX.

Cardboard tubes and other cardboard doodads

Clear plastic containers, 18" or smaller

Collage materials: calendars, greeting cards, tags, labels

Corks

Old costume jewelry

Paper of any kind

Ribbons, string, cord

Small safe metal objects (keys, chains, hardware, parts of machines, etc.)

Textiles: fabric, yarn, lace. We love textures in ArtBreak.

Wire, all kinds

Wood: small pieces and scraps, knobs, blocks, wicker strips

Anything else you might have on hand and would like to pass along.

Thank you for supporting ArtBreak!

ARTBREAK REFERRAL FORM

Student's name: _____

Classroom teacher: _____

Referred by: _____

	Primary Reason for Referral (check one)	Other Reasons (check as many as apply)
Kinesthetic/sensory reasons for referral		
Express feelings: is sad	[]	[]
Express feelings: is angry	[]	[]
Express feelings: is upset	[]	[]
Needs a chance to relax	[]	[]
Needs a break from the classroom	[]	[]
Perceptual/affective reasons for referral		
Develop empathic understanding for self or others	[]	[]
Identify feelings in self and others	[]	[]
Understand cause and effect	[]	[]
Needs to improve social skills	[]	[]
Needs to improve attention	[]	[]
Cognitive/symbolic reasons for referral		
Needs problem-solving skills	[]	[]
Needs to identify and integrate personal strengths	[]	[]

Details or other reason for referral: _____

FAMILY PERMISSION LETTER

Date

Dear Family of _____,

Your child's teacher has suggested that _____
participate this year in an ArtBreak small group. Students in ArtBreak
groups meet for forty minutes each week with me to make art with
materials of their choosing.

Children in the group accomplish social goals as well as have the
opportunity to relax and work on problem-solving skills.

*Please indicate your permission below for your child to participate in
ArtBreak; clip and return the lower half of this letter with your signature
to the school.*

Thank you very much. If you have any questions or would like to talk
about ArtBreak you can reach me at: _____.

Sincerely,

✂ ┈┈┈

Child's name: _____

[] Yes, my child may participate in ArtBreak this year.

[] No, my child may not participate.

Parent or Guardian signature: _____

Date: _____

NOTE TO FAMILIES
What to Do with Constructions

Dear ArtBreak Families,

We have begun designing and building 3D objects in ArtBreak. The children in the group conceive of their projects, then problem solve to bring them into form. I am there to assist and provide the materials and tools they need. I also work to establish each ArtBreak group as a supportive, joyful, and productive community.

Your child may be bringing home cardboard constructions, and you may be wondering what to do with these creations. Here are some suggestions:

1. Ask your child to tell you about the creation: How did she or he make it? What materials and tools did she or he use? What were the challenges?

2. Give meaningful feedback. Comments such as: "You worked really hard," and "You used your skills," are more meaningful than "I like it."

3. After a large piece has been around the house for a while, you might consider having your child take it apart and recycle the materials or use them to build new projects.

Please call, email, or stop in any time!

Sincerely,

INDIVIDUAL STUDENT DOCUMENTATION FORMS

Student: _____

Date: _____

Referral goal: _____

Media used: _____

Product notes: _____

Individual process: _____

Group process: _____

Student: _____

Date: _____

Referral goal: _____

Media used: _____

Product notes: _____

Individual process: _____

Group process: _____

Student: _____

Date: _____

Referral goal: _____

Media used: _____

Product notes: _____

Individual process: _____

Group process: _____

Student: _____

Date: _____

Referral goal: _____

Media used: _____

Product notes: _____

Individual process: _____

Group process: _____

SAMPLE ARTBREAK
PROGRESS REPORTS

ARTBREAK: FALL SEMESTER

Molly: Grade One

Molly was referred to ArtBreak to help her identify and integrate her strengths and to support her in expressing feelings appropriately. She is in an afternoon group with five other children of varying ages. They meet together weekly for forty minutes.

Molly loves to design and make constructions. She works independently and with much concentration to envision her projects, assemble materials and tools, and complete the work she lays out for herself. She has coped well with the frustrations she encounters when working on a project and is a creative problem-solver. She is developing an appreciation for, and skill with, color and design. Molly is willing to share materials when the occasion arises and offers help to others. Recently she has begun a sewing project.

You'll notice that Molly carefully numbers her ArtBreak journal entries. She likes to write about the materials she uses. As we go forward, I will be encouraging her to add a reflective sentence on her feelings about her work.

ARTBREAK: WINTER QUARTER

Joshua: Grade Two

Joshua was referred to an ArtBreak group to give him an opportunity to relax, support his social skills, and help him improve ability to pay attention and retain focus. He is in a morning group with seven other children of varying ages who meet together weekly for forty minutes.

Joshua began ArtBreak in October and spent his time exploring all the materials we offer. It was sometimes hard for him to decide on one project to pursue and complete. By late December, he began to work in a more focused way. He is now able to decide on a project, choose materials, ask for help when needed, and complete his work. Like many children his age, he enjoys finishing a project in one session so he can take it with him.

Lately, Joshua has been exploring large-scale wearable art: a wearable robot, an angel hat (a halo), and a cape. This has required him to visualize his project, measure and mark accurately, and give directions to me when I help by cutting cardboard and using hot glue. Joshua's spatial-relations skills are strong; he also demonstrates much persistence in solving problems in order to construct his projects. Recently, he has taken time to have social interactions with the other students in the group. For example, he helped another student pin together her sewing work when she was worried she would not be able to do it all by herself.

Often at the end of a session, Joshua is thinking about what his next project will be. He prefers to work with a resistive medium like sculpture construction, rather than a more fluid medium like finger paint. Resistive media support problem-solving skills, the ability to pay attention and retain focus, and the integration of personal strengths, whereas fluid media are more relaxing and expressive.

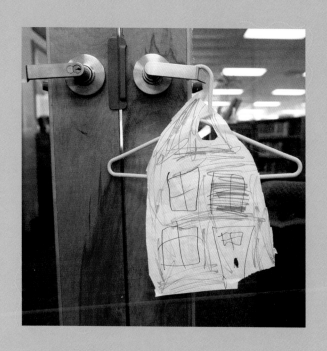

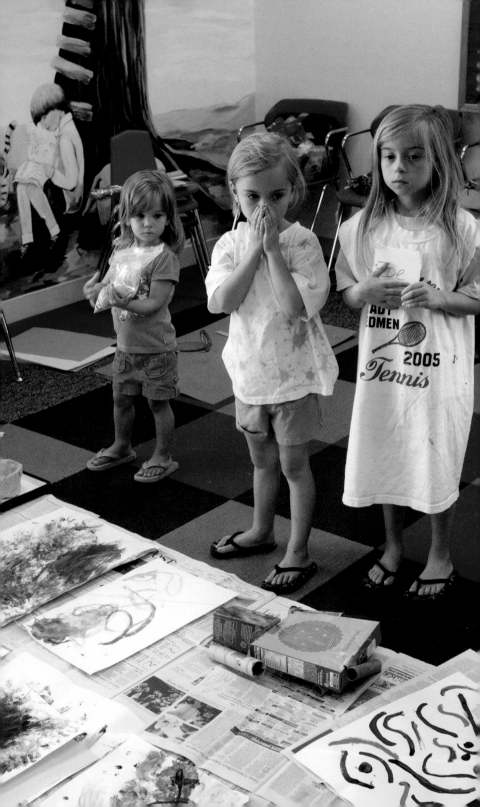

SUGGESTED READING

PREFACE

THREE KINDS of art studios circulated in my head as I planned ArtBreak. I had learned about all of them in my doctoral counselor education studies in which I pursued a cognate area in studio art and wellness, took studio art classes, and prepared research papers on the topic. I learned about Edward Adamson's work at Netherne Psychiatric Hospital, formerly Netherne Asylum, in England. An artist, Adamson was invited in 1946 to offer an art studio for patients in the hospital. He worked there until he retired in 1981, supporting hundreds of patients in self expression. Tens of thousands of works were produced by these patient-artists, who were allowed to come and go freely to Adamson's open studio.

Inspiration also came from the movement to establish art studios for persons with disabilities, a departure from the "sheltered-workshop" model. I had the great good fortune to spend volunteer hours with Patty Mitchell at Passion Works Studio in Athens, Ohio. This was when the studio was in its original location within an agency devoted to providing work for adults with developmental disabilities. Located in a gravel parking lot, between the Hocking River and Stimson Avenue, half of the building was an exuberant art studio, filled with joy and energy, in which Patty was a whirlwind—supporting artists, encouraging volunteers, and seeing to a thousand details designed to support an atmosphere of creativity and warmth. She attended effortlessly to big problem-solving questions, as well as to little things like what kind of music should be played in the studio. (The rule was no radio.) The other side of the building was given over to work that seemed dreary in comparison: assembling pens and preparing packages for mailing.

Finally, I read about the art studio for medical students that artist Mary Anne Bartley created in 1993 at the invitation of the Medical College of Pennsylvania, just after it merged with Hahnemann University Hospital. The college, originally the Female Medical College of Pennsylvania, was chartered in 1850 as the first women's medical college in the world. Hahnemann University, established in 1885, was named for Samuel Hahnemann, the founder of homeopathic medicine. Bartley's studio was a place where

high-achieving, hard-working physicians-in-training could relax, learn about art, recharge, and expand their horizons. The work of all three studios is described in these sources. Edward Adamson, *Art as Healing*; Mary Anne Bartley, "Creativity and Medicine: An Atelier in Medical School"; and Susan Dlouhy and Patty Mitchell, *Upcycling Sheltered Workshops: A Revolutionary Approach to Transforming Workshops into Creative Spaces*.

WHY ARTBREAK?

It is remarkable to think that it is necessary to construct rationales and highlight research to support the developmental value of play for children, a century after the births of psychologists Jean Piaget and Lev Vygotsky (both born in 1896) and social worker Edith Cobb (born in 1895). Their work was foundational in building theories of child play: as critical to the development of social competence (Piaget); as a fundamental element in the growth of both social and cognitive competence (Vygotsky); and, in the case of Cobb, as laying the groundwork for development of lifelong creativity and the ability to produce complex and organized fields. The work of these three theorists and philosophers is not particularly reader friendly, yet there is compelling value in reading their original works, a few examples of which are listed here: Edith Cobb, *The Ecology of Imagination in Childhood*; Jean Piaget, *Play, Dreams, and Imitation in Childhood*; and Lev S. Vygotsky, *Mind in Society: The Development of Higher Psychological Processes*.

Recently counselors, psychologists, and educators have again turned to researching and highlighting the importance of play for children, especially in school. Peter Gray analyzes the values of hunter-gatherer societies —autonomy and sharing, trustful parenting, technical skills and knowledge, social skills, and self control—and relates them to child play and social/emotional development. He is courageous in his criticism of schooling that does not support children and proposes alternatives, citing the importance of schooling that features a playful state of mind, choice, and free age-mixing in this book: Peter Gray, *Free to Learn: Why Unleashing the Instinct to Play Will Make Our Children Happier, More Self-Reliant, and Better Students for Life*.

Elise Belknap and Richard Hazler provide a thorough and convincing argument for restoring free and guided play in the lives of children at school, reviewing the literature and the benefits of play and providing suggestions for school counselors. They use Doris Bergen's continuum of play: from child-directed free play to work directed by adults but disguised as play. Among these authors and their works are: Elise Belknap and Richard

Hazler, "Empty Playgrounds and Anxious Children"; Doris Bergen, "Reconciling Play and Assessment Standards"; Allison Burck, *Relationships Among Play, Coping, Stress and Adjustment in Young Children*; Jennifer Drake and Ellen Winner, "How Children Use Drawing to Regulate Their Emotions"; and Nicole Glenn, Camilla Knight, Nicholas Holt, and John Spence, "Meanings of Play among Children."

ArtBreak is a guided-play experience that functions as a weekly "uplift" to help mitigate child stress. Psychologist Richard Lazarus introduced in 1980 the idea of daily uplifts, or experiences of positively toned emotions that can mitigate stress. Twenty years later Barrett and Huebeck explored the role of chronic school-based stress, or "school hassles" and the role of such uplifts. These concepts are explored here: Suzanne Barrett and Bernd Huebeck, "Relationships Between School Hassles and Uplifts and Anxiety and Conduct Problems in Grades 3 and 4"; and Richard Lazarus, Allen D. Kanner, and Susan Folkman, "Emotions: A Cognitive-Phenomenological Analysis."

Reports on our action research, conducted by practitioners and designed to support the program's operations and inform improvements, can be found here: Katherine Ziff, Lori Pierce, Sue Johanson, and Margaret King, "ArtBreak: A Creative Group Counseling Program for Children"; and Katherine Ziff, Nathaniel Ivers, and Edward Shaw, "ArtBreak Group Counseling for Children: Framework, Practice Points, and Results."

Support for autonomy and competence figure in an ArtBreak studio. For a description of self-directed learning, as a backdrop to understanding children's comments about ArtBreak in terms of its emphasis on self-direction of children, see: Susan Ambrose, Michael Bridges, Michele DiPietro, Marsha Lovett, Marie Norman, and Richard Mayer. *How Learning Works: Seven Research-Based Principles for Smart Teaching.* Erikson's study of the developmental tasks of age groups through the lifespan describes the work of middle childhood as developing competence in the world of people and things and can be reviewed in: Erik Erikson, *Identify and the Life Cycle.* The development of self-directed learning and competence are treated in: William Crain, *Theories of Development: Concepts and Applications.*

ArtBreak offers the related concepts of fun, joy, happiness, and school engagement, explained in more depth here: Martin Seligman, *Flourish: A Visionary New Understanding of Happiness and Well-Being*; Ming-Te Wang and Jacquelynne Eccles, "School Context, Achievement Motivation, and Academic Engagement: A Longitudinal Study of School Engagement Using a Multidimensional Perspective; and Judy Willis, *Research-Based Strategies to Ignite Student Learning: Insights From a Neurologist and Classroom Teacher.*

Finally, for the contribution of ArtBreak to a trauma-sensitive school culture see: American Psychological Association Presidential Task Force on Post-traumatic Stress Disorder and Trauma in Children & Adolescents, *Children and Trauma*; and Massachusetts Advocates for Children, *Helping Traumatized Children Learn*.

Next, we come to the quest to justify the arts in education by documenting a role for them in advancing grades and test scores. Researchers have tried to link students' participation in the arts to school achievement, as measured by grades and test scores, since at least the 1980s. In 2000 Ellen Winner and Lois Hetland published the results of their systematic meta-analyses of about two hundred studies testing the claim that arts education transferred to non-arts learning in reading, math, verbal and math test scores, and spatial reasoning. With the exception of a few areas—classroom drama transferred to an improvement in verbal skills and music instruction to improved spatial reasoning—to the dismay of arts educators, the study was unable to demonstrate a causal relationship between studying an art form and non-arts cognition.

Fifteen years later, arts-in-education researchers continue to note that, while correlational evidence links academic success to involvement with the arts, direct causal claims are very difficult to make. These researchers have sensibly concluded that the best way to increase reading and math scores, for example, is to directly teach reading and math. Research on arts experiences in schools has refocused on seeking to gain an understanding of the kinds of outcomes school-based arts experiences *do* have. For example, a follow-up study to Winner and Hetland's work documented eight studio "habits of mind" or thinking dispositions taught by visual-arts educators, such as the development of craft; engagement and persistence; and the ability to reflect, observe, envision, and express. In addition, the new interdisciplinary field of neuroaesthetics studies cognitive and emotional responses to school-based involvement with the arts in an effort to understand the role of the arts in well-being. Reports on this research are here:

Elviar Brattico and Marcus Pearce, "The Neuroaesthetics of Music"; Madden, Karl, David Orenstein, Alexei Oulanov, Yelena Novitskaya, Ida Bazan, Thomas Ostrowski, and Min Hyung Ahn, "Music Education, Aesthetics, and the Measure of Academic Achievement"; Ellen Winner, Thalia R. Goldstein, and Stephan Vincent-Lancrin, *Art for Art's Sake? The Impact of Arts Education*; Ellen Winner and Lois Hetland, "The Arts and Academic Achievement: Evaluating the Evidence for a Causal Link"; and Ellen Winner, Lois Hetland, Shirley Veenema, Kim Sheridan, and Patricia

Palmer, "Studio Thinking: How Visual Arts Teaching Can Promote Disciplined Habits of Mind."

A CREATIVE FRAMEWORK

Toward the end of his career Carl Rogers began to apply his person-centered approach to education, resulting in his student-centered approach to teaching and learning presented in: Carl R. Rogers, *Freedom to Learn*. Two recent works highlight the importance of social/emotional aspects of schooling: Jennifer Barna and Pamela Brott, "How Important Is Personal/Social Development to Academic Achievement"; and Rena Subotnik and Robert Sternberg, *Optimizing Student Success in School with the Other Three R's: Reasoning, Resilience, and Responsibility*.

The list of questions for a facilitator to consider in developing awareness of culture and diversity within an ArtBreak group are based on these works, which are very much worth reading in their entirety: Paula Howie, Sangeeta Prasad, and Jennie Kristel, *Using Art Therapy with Diverse Populations: Crossing Cultures and Abilities*; and Derald Wing Sue and David Sue, *Counseling the Culturally Diverse: Theory and Practice*.

The expressive therapies continuum, introduced by art therapists Vija Lusebrink and Sandra Kagin, is thoroughly explained in: Lisa Hinz, *Expressive Therapies Continuum: A Framework for Using Art in Therapy*; Sandra Kagin and Vija Lusebrink, "The Expressive Therapies Continuum"; and Vija Lusebrink. "Assessment and Therapeutic Application of the Expressive Therapies Continuum: Implications for Brain Structures and Functions."

Ellen Winner and her colleagues sort out child creativity in their volume *Art for Art's Sake* by using the "Big-C" and "little-c" creativity distinction. Children are able to engage in "little-c" creativity, while it is adults, immersed in the mastery of a domain, who can produce "Big-C" creative activities and directions. Their book makes these two distinctions nicely and explains how it is that children may engage in creativity. Nobel Prize winners exemplify Creativity, and the catalog of the Nobel Museum in Stockholm presents the work of individual, "Big-C" creativity. The volume also presents the idea of creative milieus, or environments and places that have stimulated creativity, such as Long Island's Cold Spring Harbor with its environmental science laboratories, Paris between the two World Wars as a place of experimentation in literature and art, and the groundswell of new Japanese literature in post–World War II Tokyo. Of course, Mihaly Csikszentmihalyi's work on creativity and the psychology of discovery and

invention is a classic, with its descriptions of individual biographies and creative process. These are presented in: Winner, Goldstein, and Vincent-Lancrin, *Art for Art's Sake*; Ulf Larsson's book on the Nobel Museum in Stockholm, *Cultures of Creativity: Birth of a 21st Century Museum*; and in Mihaly Csikszentmihalyi, *Creativity: The Psychology of Discovery and Invention*. In contrast to Csikszentmihalyi's position on creativity, Vlad Petre Glaveanu makes a modest proposal for a more comprehensive definition of creativity that does not distinguish between its "higher" and "lower" forms. Taking this cultural perspective on creativity as connected to everyday life recognizes that children are driven by active and creative involvement in with their world. This position is presented in his article entitled *Children and Creativity: A Most (Un)likely Pair?*

A half-century ago, Bruce Tuckman proposed four stages of group development that are necessary for a group to work and grow: forming, storming, norming, and performing. Later a fifth stage, ending, was added. This has become a foundational framework for small-group counseling and is described in Samuel Gladding, *Counseling: A Comprehensive Profession*.

MATERIALS AND TOOLS

Several books from the field of art education have been helpful in developing an ArtBreak studio. They range from the theoretical to the practical. Winston Churchill's little book, *Painting as a Pastime*, on his journey as a painter is included here as it is an example of a beginner, self-taught and encouraged by friends. Katherine Douglas and Diane Jaquith's book, *Engaging Learners through Artmaking: Choice-Based Art Education*, is a comprehensive guide to choice-based art education written by masterful art educators. I had the opportunity to attend a workshop given by George Szekeley, professor of art education, who has devoted his career to the importance of children's play in art making; his work as a teacher is in a league with Alexander Calder as a proponent of creativity and play. See George Szekeley, *How Children Make Art: Lessons in Creativity from Home to School*. Finally, Ruth Faison Shaw pioneered and originated finger painting as we know it today. Her work is hard to find but, having done so and experimented with her method in ArtBreak studios, I found it to be entirely child-centered, giving order and delight and incorporating narrative into the process. See Ruth Faison Shaw, *Finger Painting and How I Do It* and *Finger Painting: A Perfect Medium for Self-Expression*. Other recommended titles are: Molly Campbell and Alex Truesdell. *Creative Construc-*

tions: *Technologies that Make Adaptive Design Accessible, Affordable, Inclusive, and Fun*; Carolyn Edwards, Lella Gandini, and George Forman, eds., *The Hundred Languages of Children: The Reggio Emilia Experience in Transformation*; Lella Gandini, Lynn Hill, Louise Cadwell, and Charles Schwall, *In the Spirit of the Studio: Learning from the Atelier of Reggio Emilia;*. Diane Jaquith and Nan Hathaway. *The Learner-Directed Classroom: Developing Creative Thinking Skills through Art*; and Nancy Smith. *Experience and Art: Teaching Children to Paint.*

Many resources are available to counselors offering art making to their clients. Sam Gladding introduced me to creative counseling when I was studying counseling at Wake Forest in the early 1990s, through the work of John Allen as well as with his own classic and perennially fresh guide to creative counseling; Catherine Moon's book is a personal account of incorporating studio art into therapy, and Judith Rubin's work is invaluable in developing a child-centered perspective. See: Samuel Gladding, *The Creative Arts in Counseling*; John Allan, *Inscapes of the Child's World*; Catherine Moon, *Studio Art Therapy: Cultivating the Artist Identity in the Art Therapist*; and Judith Rubin, *Child Art Therapy: Understanding and Helping Children Grow through Art.*

Finally, the "scribble chase" given for experiencing marker, colored pencils, or crayons, and for encouraging a child who is reluctant to draw, is a time-honored art-therapy exercise. It is described in detail in the first chapter of Lisa Hinz' book, *Expressive Therapies Continuum.*

PROCEDURES

Clyde Gaw and Gerard Jones have thought deeply and written about images of violence that children create. Their guidance can be found here: Clyde Gaw, "The Secret Art of Boys"; and Gerard Jones, *Killing Monsters: Why Children Need Fantasy, Super Heroes, and Make-Believe Violence.*

WORKS CITED

Adamson, Edward. *Art as Healing*. London: Coventure, Ltd, 1991.

Allan, John. *Inscapes of the Child's World*. Washington, DC: Spring Publications, 1998.

Ambrose, Susan, Michael Bridges, Michele DiPietro, Marsha Lovett, Marie Norman, and Richard Mayer. *How Learning Works: Seven Research-Based Principles for Smart Teaching*. New York: Jossey-Bass, 2010.

American Psychological Association Presidential Task Force on Posttraumatic Stress Disorder and Trauma in Children & Adolescents. *Children and Trauma*. Washington, DC: American Psychological Association, 2009.

Ayres, Julia. *Monotype: Mediums and Methods for Painterly Printmaking*. New York: Crown Publishing, 2001.

Barna, Jennifer, and Pamela Brott. "How Important Is Personal/Social Development to Academic Achievement?" *Professional School Counseling* 14 (2011): 242–49.

Barrett, Suzanne, and Bernd Huebeck. "Relationships Between School Hassles and Uplifts and Anxiety and Conduct Problems in Grades 3 and 4." *Journal of Applied Developmental Psychology* 21 (2000): 537–54.

Bartley, Mary Anne. "Creativity and Medicine: An Atelier in Medical School." *International Journal of Arts Medicine* 5 (1997): 36–39.

Belknap, Elise, and Richard Hazler. "Empty Playgrounds and Anxious Children." *Journal of Creativity in Mental Health* 9 (2014): 210–31.

Bergen, Doris. "Reconciling Play and Assessment Standards." In *Play from Birth to Twelve*, edited by Doris Pronin Fromberg and Doris Bergen, 233–40. New York: Routledge, 2006.

Berlin, Bernie. *Artist Trading Card Workshop: Create, Collect, Swap*. Cincinnati: North Light Books, 2007.

Brattico, Elviar, and Marcus Pearce. "The Neuroaesthetics of Music." *Psychology of Aesthetics, Creativity, and the Arts* 7 (2013): 48–61.

Burck, Allison. *Relationships Among Play, Coping, Stress, and Adjustment in Young Children*. Doctoral dissertation: Case Western Reserve University, 2011.

Campbell, Molly, and Alex Truesdell. *Creative Constructions: Technologies that Make Adaptive Design Accessible, Affordable, Inclusive, and Fun*. Cambridge, MA: Molly Campbell, 2002.

Chanin, Natalie, and Stacie Stukin. *Alabama Stitch Book: Projects and Stories Celebrating Hand-Sewing, Quilting, and Embroidery for Contemporary Sustainable Style.* New York: Stewart, Tabori, and Chang, 2008.

Churchill, Winston. *Painting as a Pastime.* New York: Cornerstone Library, 1965.

Clinch, Moira. *The Watercolor Painter's Pocket Palette.* Cincinnati: North Light Books, 1991.

Cobb, Edith. *The Ecology of Imagination in Childhood.* New York: Columbia University Press, 1977.

Crain, William. *Theories of Development: Concepts and Applications.* Essex, UK: Pearson, 2010.

Csikszentmihalyi, Mihaly. *Creativity: The Psychology of Discovery and Invention.* New York: Harper Perennial, 1996.

Dlouhy, Susan, and Patty Mitchell. *Upcycling Sheltered Workshops: A Revolutionary Approach to Transforming Workshops into Creative Spaces.* Athens, OH: Swallow Press, 2015.

Douglas, Katherine M., and Diane B. Jaquith. *Engaging Learners through Artmaking: Choice-Based Art Education.* New York: Teachers College Press, 2009.

Drake, Jennifer, and Ellen Winner. "How Children Use Drawing to Regulate Their Emotions." *Cognition & Emotion* 27 (2013): 512–20.

Edwards, Betty. *Drawing on the Right Side of the Brain: The Definitive, 4th Edition.* New York: TarcherPerigee, 2012.

Edwards, Carolyn, Lella Gandini, and George Forman, eds. *The Hundred Languages of Children: The Reggio Emilia Experience in Transformation.* Santa Barbara, CA: Praeger, 2012.

Erikson, Erik. *Identify and the Life Cycle.* New York: W. W. Norton, 1994.

Fincher, Susanne F. *Creating Mandalas: For Insight, Healing, and Self-Expression.* Boulder: Shambhala Publications, 2010.

Gandini, Lella, Lynn Hill, Louise Cadwell, and Charles Schwall, *In the Spirit of the Studio: Learning from the Atelier of Reggio Emilia.* New York: Teachers College Press, 2005.

Gaw, Clyde. "The Secret Art of Boys." In *The Learner-Directed Classroom: Developing Creative Thinking Skills Through Art,* edited by Diane Jaquith and Nan Hathaway, 107–19. New York: Teachers College Press, 2012.

Glaveanu, Vlad Petre. "Children and Creativity: A Most (Un)likely Pair?" *Thinking Skills and Creativity* 2 (2011): 122–31.

Glenn, Nicole, Camilla Knight, Nicholas Holt, and John Spence. "Meanings of Play Among Children." *Childhood* 2 (2012): 185–99.

Gladding, Samuel T. *Counseling: A Comprehensive Profession.* Upper Saddle River, NJ: Pearson, 2009.

———. *The Creative Arts in Counseling.* Alexandria: American Counseling Association, 2011.

Gray, Peter. *Free to Learn: Why Unleashing the Instinct to Play Will Make Our Children Happier, More Self-Reliant, and Better Students for Life.* Philadelphia: Basic Books, 2013.

Hinz, Lisa. *Expressive Therapies Continuum: A Framework for Using Art in Therapy.* New York: Routledge, 2009.

Howie, Paula, Sangeeta Prasad, and Jennie Kristel, eds. *Using Art Therapy with Diverse Populations: Crossing Cultures and Abilities.* London: Jessica Kingsley, 2013.

Jaquith, Diane, and Nan Hathaway. *The Learner-Directed Classroom: Developing Creative Thinking Skills through Art.* New York: Teachers College Press, 2012.

Jones, Gerard. *Killing Monsters: Why Children Need Fantasy, Super Heroes, and Make-Believe Violence.* New York: Basic Books, 2002.

Kagin, Sandra, and Vija Lusebrink. "The Expressive Therapies Continuum." *Art Psychotherapy* 5 (1978): 171–80.

Landreth, Gary L. *Play Therapy: The Art of the Relationship.* New York, NY: Routledge, 2012.

Larsson, Ulf. *Cultures of Creativity: Birth of a 21st-Century Museum.* Sagamore Beach: Science History Publications/USA, 2006.

Lazarus, Richard, Allen D. Kanner, and Susan Folkman. "Emotions: A Cognitive-Phenomenological Analysis." In *Emotion: Theory, Research, and Experience,* edited by Robert Plutchik and Henry Kellerman, 189–218. New York: Academic Press, 1980.

Lusebrink, Vija. "Assessment and Therapeutic Application of the Expressive Therapies Continuum: Implications for Brain Structures and Functions." *Art Therapy: Journal of the American Art Therapy Association* 27, no. 1 (2010): 168–77.

Madden, Karl, David Orenstein, Alexei Oulanov, Yelena Novitskaya, Ida Bazan, Thomas Ostrowski, and Min Hyung Ahn. "Music Education, Aesthetics, and the Measure of Academic Achievement." *Creative Education* 5 (2014): 1740–44.

Massachusetts Advocates for Children. *Helping Traumatized Children Learn.* Boston: MAC Trauma and Learning Policy Initiative Publications, 2010.

Moon, Catherine. *Studio Art Therapy: Cultivating the Artist Identity in the Art Therapist.* London: Jessica Kingsley, 2002.

Packer, Bevill. *Appropriate Paper-Based Technology (APT): A Manual.* London: Intermediate Technology Publications Ltd., 1995.

Piaget, Jean. *Play, Dreams, and Imitation in Childhood.* New York: W. W. Norton, 1962.

Rogers, Carl R. *The Carl Rogers Reader.* Edited by Howard Kirschenbaum and Valerie Land Henderson. Boston: Houghton Mifflin, 1989.

Rogers, Carl R. *Freedom to Learn.* Columbus, OH: Charles E. Merrill Publishing, 1969.

Rubin, Judith. *Child Art Therapy: Understanding and Helping Children Grow Through Art.* New York: Van Nostrand Reinhold, 2005.

Seligman, Martin. *Flourish: A Visionary New Understanding of Happiness and Well-Being.* New York: Free Press, 2011.

Shaw, Ruth Faison. *Finger Painting and How I Do It.* New York: Leland-Brent Publishing, 1947.

———. *Finger Painting: A Perfect Medium for Self-Expression.* Boston: Little, Brown, 1934.

Smith, Nancy. *Experience and Art: Teaching Children to Paint.* New York: Teachers College Press, 1993.

Subotnik, Rena Faye, and Robert J. Sternberg. *Optimizing Student Success in School with the Other Three Rs: Reasoning, Resilience, and Responsibility.* Charlotte, NC: Information Age Publishing, 2006.

Sue, Derald Wing, and David Sue. *Counseling the Culturally Diverse: Theory and Practice.* Hoboken: John Wiley and Sons, 2013.

Szekeley, George. *How Children Make Art: Lessons in Creativity from Home to School.* New York: Teachers College Press, 2006.

Vygotsky, Lev S. *Mind in Society: The Development of Higher Psychological Processes.* Cambridge, MA: Harvard University Press, 1978.

Wang, Ming-Te, and Jacquelynne Eccles. "School Context, Achievement Motivation, and Academic Engagement: A Longitudinal Study of School Engagement Using a Multidimensional Perspective." *Learning and Instruction* 28 (2013): 12–23.

Willis, Judy. *Research-Based Strategies to Ignite Student Learning: Insights from a Neurologist and Classroom Teacher.* Alexandria: Association for Supervision and Curriculum Development, 2007.

Winner, Ellen, Thalia R. Goldstein, and Stephan Vincent-Lancrin. *Art for Art's Sake? The Impact of Arts Education.* Paris: OECD Publishing, 2013.

Winner, Ellen, and Lois Hetland. "The Arts and Academic Achievement: Evaluating the Evidence for a Causal Link." *Journal of Aesthetic Education,* 34 (2000): 3–10.

Winner, Ellen, Lois Hetland, Shirley Veenema, Kim Sheridan, and Patricia Palmer. "Studio Thinking: How Visual Arts Teaching Can Promote Disciplined Habits of Mind." In *New Directions in Aesthetics, Creativity, and the Arts,* edited by Paul Locher, Colin Martindale, and Leonid Dorfman, 189–205. Amityville, NY: Baywood Publishing, 2006.

Ziff, Katherine, Nathaniel Ivers, and Edward Shaw. "ArtBreak Group Counseling for Children: Framework, Practice Points, and Results." *The Journal for Specialists in Group Work* 41 (2016): 71–92.

Ziff, Katherine, Lori Pierce, Sue Johanson, and Margaret King. "ArtBreak: A Creative Group Counseling Program for Children." *Journal of Creativity in Mental Health* 7 (2012): 108–20.

INDEX

academics: arts and, 8–9, 23, 144–45;
 engagement, 143; social and emo-
 tional learning and, 25
accommodations, 87
acrylic paint, 40, 59, 64, 66, 81, 127
affective: ETC level, 40, 42; goals, 7,
 39, 40, 41, 132
Alabama Stitch Book, 72
American Psychological Association, 21,
 25, 144
American School Counselor Associa-
 tion, 25
Appalachia, 34
Athens, Ohio, xi, 141
awl, 23, 27, 70, 71, 76, 84, 85, 115, 126

bone folder, 76, 128
brads, 32, 77
brass fasteners, 23, 43, 45, 70, 77, 84, 85,
 107, 114–15, 116. *See also* brads
breathers, 10

cardboard, xi, 4, 8, 16, 17, 18, 19, 23, 27,
 29, 34, 37, 38, 41, 43, 44, 45, 47, 49,
 54, 55, 59, 60, 62, 64, 65, 66, 68,
 69, 70, 71, 75, 76, 78, 81, 84, 85,
 98, 101, 107, 108, 109, 113, 114, 115,
 116, 125, 126, 129, 131, 134, 138
cause and effect, 7, 22, 39, 40, 41, 132
chalk pastels. *See* pastels
child-centered education, ix–x, 24–38,
 146. *See also* student-centered
 education
child-centered environment, x, 50, 82,
 146, 147
choice, 5, 7, 12, 15, 19, 21, 22, 28, 29, 30,
 43, 47, 53, 55, 56, 61, 82, 85, 90,
 108, 109, 110–12, 116, 129, 142, 146
Churchill, Winston, 58, 146
clay, 4, 17, 33, 40, 55, 64, 72, 90, 128

cleaning, 9, 27, 50, 53, 54, 61, 67, 76,
 79–81, 86, 88, 89, 109, 120, 126
cleanup, 8, 27, 83, 97, 107, 108, 110–12,
 113, 126
cognitive activity, 13, 68
cognitive competence, 142
cognitive development, 43
cognitive-executive functions, 22
cognitive flexibility, 4
cognitive process, 13, 45
cognitive responses, 144
cognitive skills, x, 14–19, 21, 22, 40, 72
cognitive/symbolic level, 42; referrals
 based on, 132
cognitive work, 64
collaboration, xi, 6, 14, 17, 24, 46, 48,
 49, 69, 100
collage, 7, 8, 15, 36, 39, 40, 41, 53, 65,
 66, 67, 68, 69, 71, 80, 85, 88, 107;
 introducing, 113–14; materials,
 65–67, 125, 131
colored pencils. *See* pencils
community, x, xi, 5, 7, 13–14, 17, 21, 23,
 24, 34, 36, 41, 49, 50, 52, 89, 92, 93,
 99, 100–102, 134
complexity, 43, 45
considerations, 9, 32, 43, 92, 98–103
construction, 7, 8, 22, 32, 39, 40, 41, 53,
 57, 59, 60, 64, 67, 68, 70, 72, 74,
 77, 80, 81, 83, 88, 101, 107, 113, 134,
 137, 138; introducing, 114–17; ma-
 terials, 67–72, 126, 127–28
counseling, ix, 24, 25, 35, 56; creative,
 ix, 147; group, ix, 24, 46–50, 146
crayons, 39, 40, 41, 43, 53, 56, 57, 108,
 125, 147
creativity, ix, 4, 5, 19, 23, 32, 45, 85, 103,
 141, 142, 145–46
critique, 30, 119
cultural diversity, 35, 145